THOMAS McKNIGHT

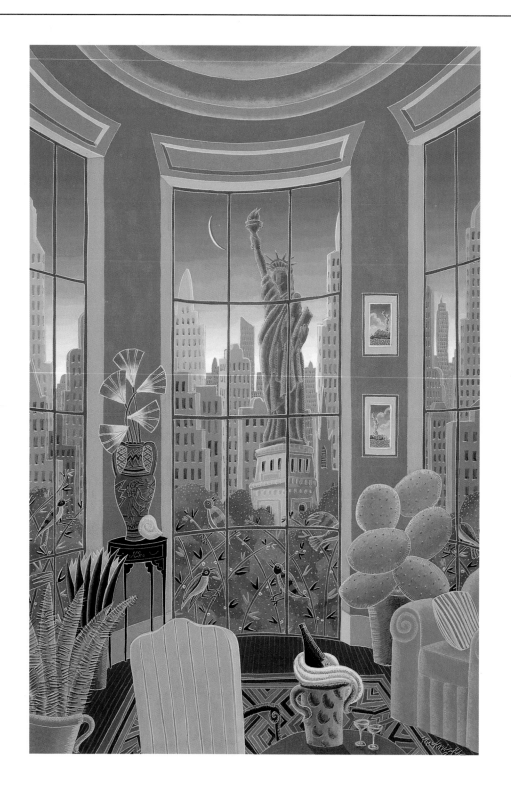

THOMAS McKNIGHT

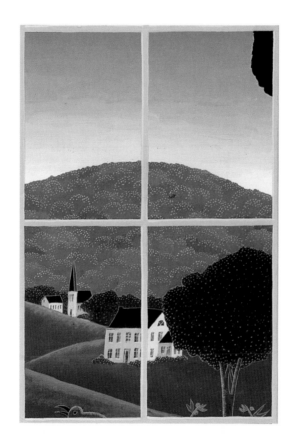

INTRODUCTION BY GENE THORNTON

HUGH LAUTER LEVIN ASSOCIATES, INC., NEW YORK

DISTRIBUTED BY THE SCRIBNER BOOK COMPANIES

FOR MY MOTHER, THE BEGINNING;
FOR MY WIFE, RENATE, THE CHAPTERS IN BETWEEN

Frontispiece
Statue of Liberty. 1984.
Casein on paper, 23 × 15″.
Collection the artist

Title page
Detail of *Litchfield*. 1984.
Casein on canvas, 38 × 42″.
Collection the artist

Dustjacket illustrations
Front: *Open Window*. 1983. Casein on canvas, 28 × 30″.
Private collection
Back: *Narcissus*. 1982. Casein on canvas, 24 × 26″. Collection
the artist

Introduction © 1984 Gene Thornton
Text and illustrations © 1984 Thomas McKnight

ISBN 0-88363-484-8

Photographic Credits
Page 108: Xystus Studio
All other photographs: David Lubarsky

Printed in Japan

TABLE OF CONTENTS

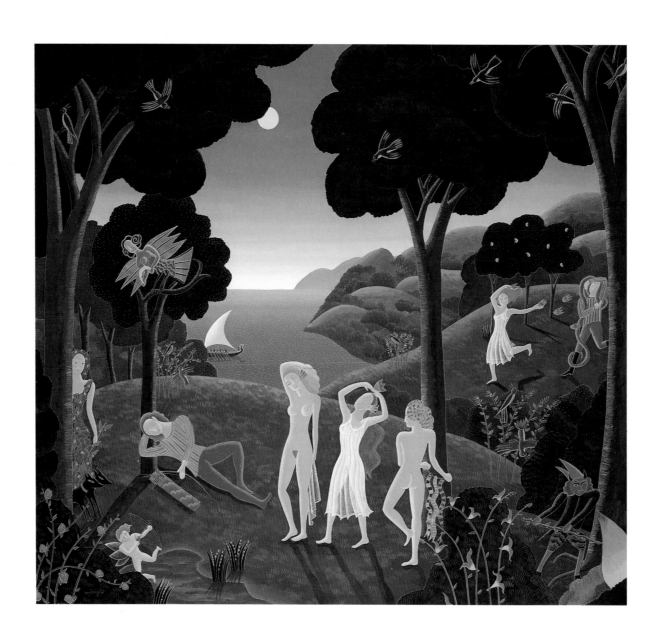

Arcadia. 1984. Casein
on canvas, 48 × 52″.
Collection the artist

THE VISIONARY REALISM OF THOMAS MCKNIGHT

BY GENE THORNTON

Thomas McKnight stands at an odd angle to the art of our time. Unlike most other American realists, he works not from nature but from imagination. Even his most factual paintings, the views of Venice done in the past year or so, glow with a light that comes not from the sun but from a vision of earthly happiness that is almost celestial, while the most obviously imaginative of his works, the allegories and mythologies filled with dancing nymphs, timid monsters and rainbow-colored birds unknown to ornithology, are far more magical than realist.

Indeed, it is scarcely correct to speak of Thomas McKnight as a realist at all. Although his pictures are full of detail, and everything in them is clearly recognizable for what it is, he habitually disregards the laws of perspective. His figure drawing is innocent of anatomy, and the flat, almost cut-out look of his trees, hills and waters gives his landscapes more the appearance of stage scenery than of anything closely observed from nature.

I call him a realist only because in our time (which is also his time) the term "realism," which used to have a precise meaning, has come to be used very loosely as an antonym for "abstrac-

tion." *Realism and Abstraction in American Painting*—we have all seen books and exhibitions with this sort of title, and if these are the only two choices, if an artist of our time must be one or the other, then Thomas McKnight is certainly a realist.

He is, however, a special kind of realist. "Show me an angel and I will paint one," said the nineteenth-century realist Gustave Courbet, declaring his intention to paint only things he could see with his own eyes. Even when Courbet's paintings were made up in the studio, as some of the most famous were, they were always squarely based on visible nature.

The next generation of painters carried realism even further, going out of the studio to work directly from nature in the open air. Monet sat in front of his haystacks when he painted them, and even the nineteenth-century academic painters, who painted historical scenes and allegories in the studio, worked from photographic documents and costumed models, investing their "imaginary" scenes with such a camera-like fidelity to nature that their paintings look more like stills from a movie by Cecil B. DeMille than the paintings of the old masters they claimed descent from.

From this kind of realism Thomas McKnight is exempt. His pictures are photographic, if at all, only in their abundance of detail. Even when they represent real things, they are made up in his head—for example, his pictures of New York City. Thomas McKnight lives in New York, and all he has to do to see the city is look out the window. But when he paints the city he turns his back to the window and paints a New York that exists only in his imagination.

No one would mistake his New York for any other city, but no one could identify more than one or two of its buildings. Some of his pictures of New York are views of the skyline seen across Central Park through the windows of a room that, if it were a real room, would be located in a tall building in the middle of the park, where no such buildings exist. Other pictures show a Central Park where hunters roam in winter or where, in summer, creatures from a strange mythology are perfectly at home. The clue to the secret of Thomas McKnight's New York is in the skyline. Most of the tall buildings have the pointed spires that are characteristic of the city not as it is today, but as it was thirty or forty years ago. What Thomas McKnight is painting is not New York as he knows it now but New York as he dreamed it when he was a boy and knew the city only as a fabulous distant place.

This visionary quality sets Thomas McKnight apart from other contemporary American realists, from cityscape painters like Gabriel Laderman, whose every building is a portrait from life, from figure painters like Alfred Leslie, whose sitters are almost painfully true to life, from painters of classical myths like Bruno Civitico and Milet Andrejevic, whose gods, nymphs and heroes look like ordinary Americans on a picnic in a park. All of these modern American realists strive for correctness of anatomy, perspective and lighting in a way that puts them in the mainstream of post-Renaissance Western painting. However, there is little that is mainstream about Thomas McKnight. Even the ordinary people in his pictures have a mythological look, and the viewer seldom knows what time of day it is, or even whether it is day or night, for the moon in the sky may say night while the light on the ground says day.

If Thomas McKnight has any artistic ancestors—and I am uncertain whether he does or not; I think he may be a true original—they are William Blake and le Douanier Rousseau. I do not mean that he has taken these artists as masters and tried to imitate their works—he has not—but that his own works have similar roots in a personal vision that cannot be fully expressed by traditional means. Neither Blake nor Rousseau was a revolutionary artist in the

Boutique of Dr. Caligari. 1982.
Casein on canvas,
24 × 28″. Private collection

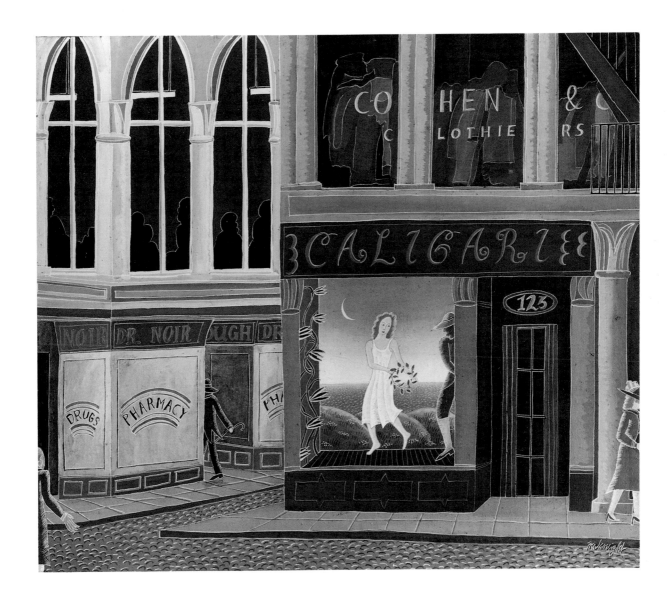

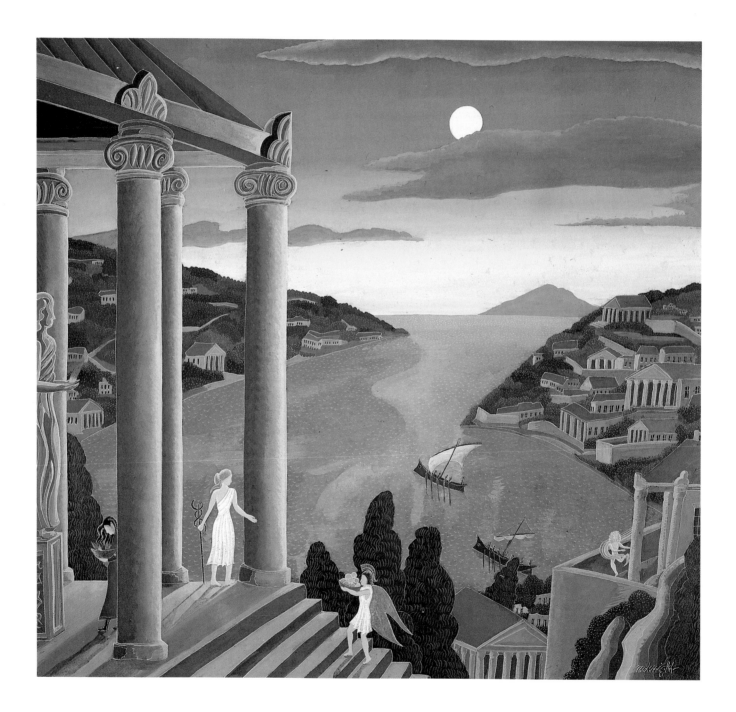

Opposite
Classical Fable. 1981.
Casein on canvas,
28 × 30″. Private
collection, New York

Manhattan Penthouse. 1983.
Casein on paper, 14 × 16″.
Collection the artist

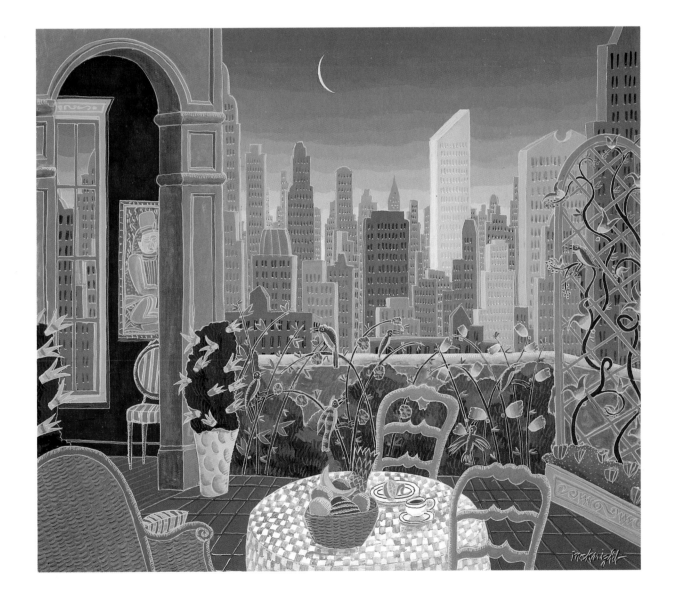

sense of wanting to overthrow traditional ways of drawing and painting. On the contrary, both loved tradition. Blake was an admirer of Michelangelo and tried (though with indifferent success) to imitate his style. Rousseau attempted to paint like the celebrated academic masters of his day, with results that were, by academic standards, laughable. Each, however, was obsessed with a vision that no preexisting style could adequately express, and each in his own way put elements of the style he admired at the service of his vision, producing works of originality and charm that have outlasted the works of all but the greatest of their better-trained and more skillful contemporaries.

Thomas McKnight shares with Blake and Rousseau an obsessive vision and a technique based on a love of old painting. Among the painters of the past that he most admires are the Italians of the early Renaissance, particularly Botticelli, and some of his allegories were conceived in conscious admiration of their works. He is, however, a child of the twentieth century, with a twentieth-century range of experience and set of expectations, and the vision realized in his paintings is one that was unknown before the late eighteenth century.

It is the vision of an earthly paradise that exists in the here and now, not in some distant past or remote, legendary land, a contemporary if slightly fabulous world that is filled with the pleasures and happiness of life and yet is not selfish or evil or rooted in the sufferings of others.

That there is something unreal about this world goes without saying, and it is appropriate that it should be presented more as a vision than a reality. But there is also something deeply appealing about it that goes beyond mere escapism. In our time, even so simple a pleasure as a chair pulled up to a fire in a well-furnished room is increasingly hard to come by, while Venice—the real Venice, not the one in his paintings—is smelly and dirty and filled with the kind of people we have come halfway round the world to get away from. Thomas McKnight's pictures remind us of how good life can be in those rare moments when all is well in the world.

Overleaf
Sacred Wood. 1981.
Casein on canvas, 28 × 30″.
Private collection

Piazza San Marco. 1983.
Casein on paper, 14 × 16″.
Collection the artist

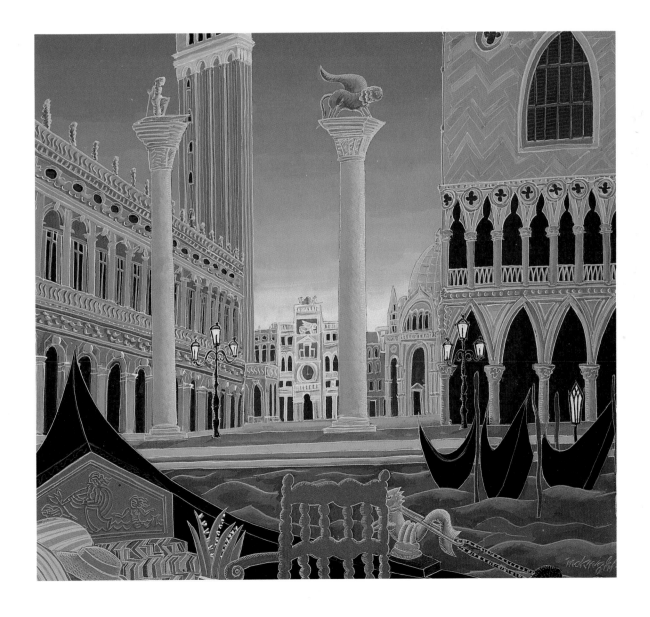

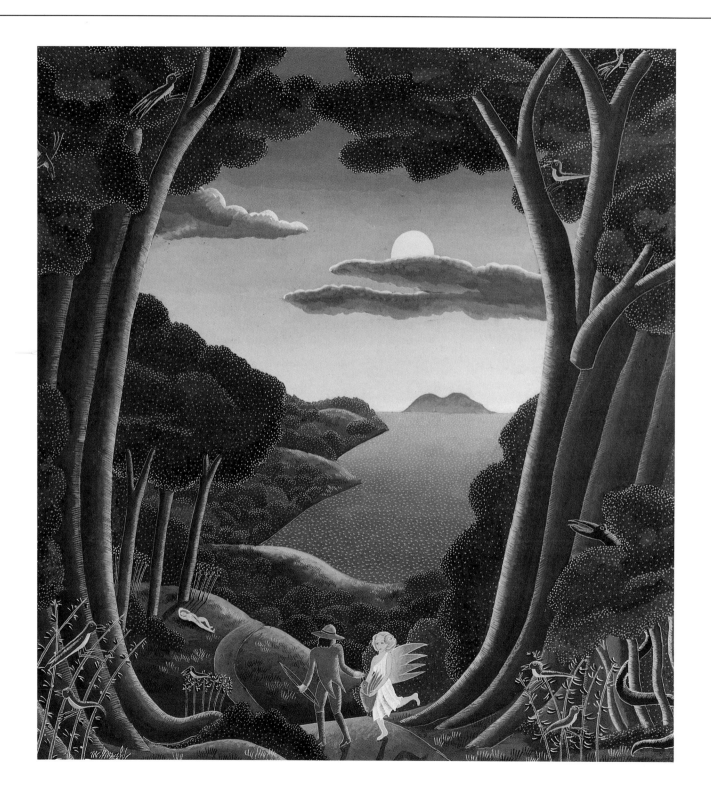

PREFACE

*Dream prepares the way for action; man
must first dream before he can do it.*

Peter Fuller, *Beyond the Crisis in Art,*
London, 1980

Why does an artist paint the way he does? That is a question I often asked myself while still a youth, when all styles and subject matter seemed equally valid and accessible. One week I was poring over Frederic Taubes's recipes for paint formulas of the old masters, the next I was dribbling lacquer paint onto a hardboard panel on the floor à la Jackson Pollack. "But what is me?" I would ask myself. Whether I knew it or not at the time, all this eclectic activity was serving a useful function—I was learning which techniques and images resonated with my inner self, and which did not.

Even in my twenties I did not cease experimenting, and I led myself down many garden paths to dead ends because of it. But then I corrupted myself by attempting to answer the question, "What kind of art is most valid for the times we live in?," and, more perniciously, "What do the critics think it should be?" I worked thickly with palette knives. I made collages of words and cigarette packs. I painted thinly with Day-Glo dots. But none of it managed to answer another question that lay even deeper: "What satisfies *me*, what kinds of techniques will bring forth the images I feel the need for at the deepest level?"

A seed, however, had been planted early, and although I did not realize it until I was almost thirty, it had been growing for a long time. A certain kind of imagery painted a certain way that was increasingly capable of conveying the meanings of what I am—or what I was when I painted the picture—became more dominant. Certain motifs recurred regularly with a significance beyond themselves. What the rest of the art world concerned itself with became less and less a matter of concern to me. The images were more important than the answer to any question of current validity. In fact, I realized that the only response to the question, "What should I paint?," comes from the artist himself when he is truest to himself. Forget what is chic this season, what Leo Castelli is showing, what people have on their walls in the glossy pages of *Art News*. Forget what Greenberg or Rosenberg or Steinberg said. Forget what has gone before and what the critics say should come afterward.

Although I do not consciously will it, certain motifs keep coming back. The images of nymphs

Opposite
Long Island Fall. 1982.
Casein on canvas,
28 × 30″. Collection
Renate McKnight, New York

Orpheus. 1980. Casein
on canvas, 24 × 26″.
Private collection, New York

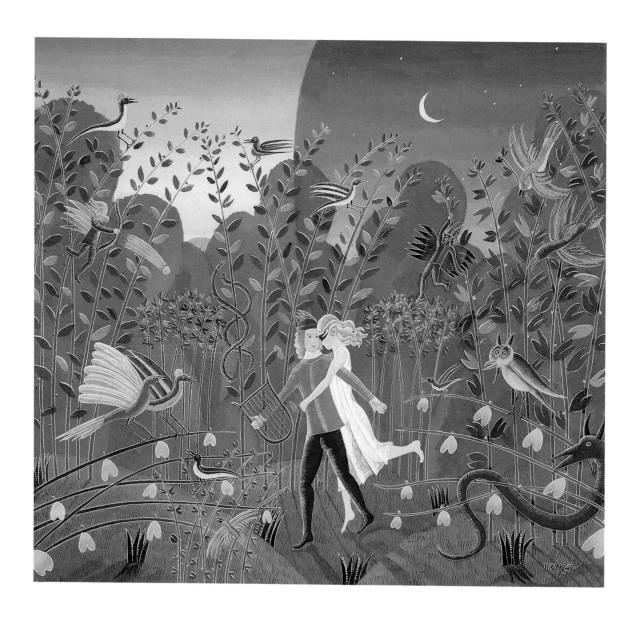

Overleaf left
Above Central Park. 1981.
Casein on canvas,
26 × 24″. Collection
Mr. Alan R. Gronsbell,
New York

Overleaf right
Fire and Water. 1983. Casein
on canvas, 30 × 28″.
Private collection, Philadelphia

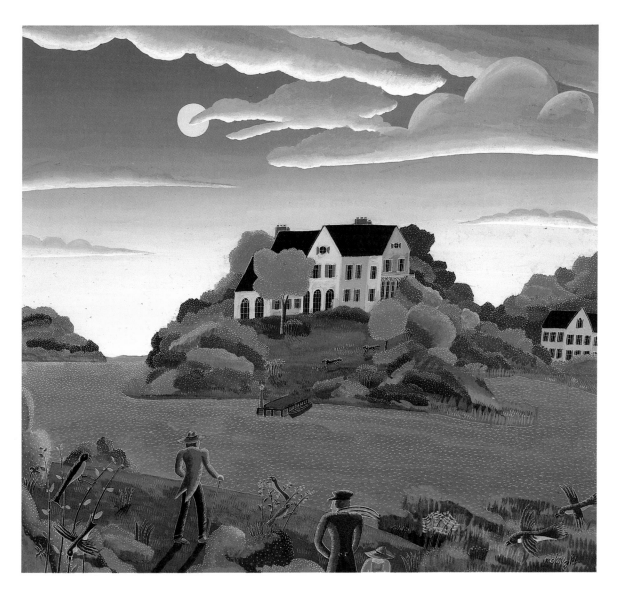

accosting men or men chasing nymphs for some reason have significance for me. Variations on this theme continually reappear in different guises—as Apollo and Daphne, as a musician singing to a nymph, as a nymph knocking over a man in a thicket.

One could psychoanalyze the motif for its bearing on my relationship with women; or one could spiritualize that and examine its relationship to my artistic muse or *anima*; or one could place all kinds of intellectual freight on an interpretation of it. As a painter, however, my interest must be that it satisfies something within me. Other things being equal—whether it succeeds as a painting or not, for example—I feel it works if upon completion it is surrounded with a numinous glow. When it is good it is capable of resonating and creating new visions. It can even open up doors to new emotions.

I had to remember to stick to only what was most magical to me, what images made me shudder with joy or fear or nostalgia. I had to learn how to stay close to the source, and at the same time to develop a technical craft that could communicate an approximation of what I felt.

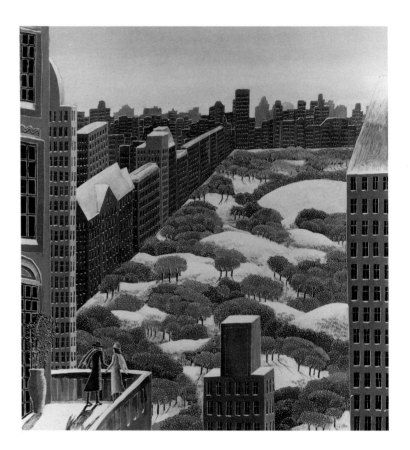

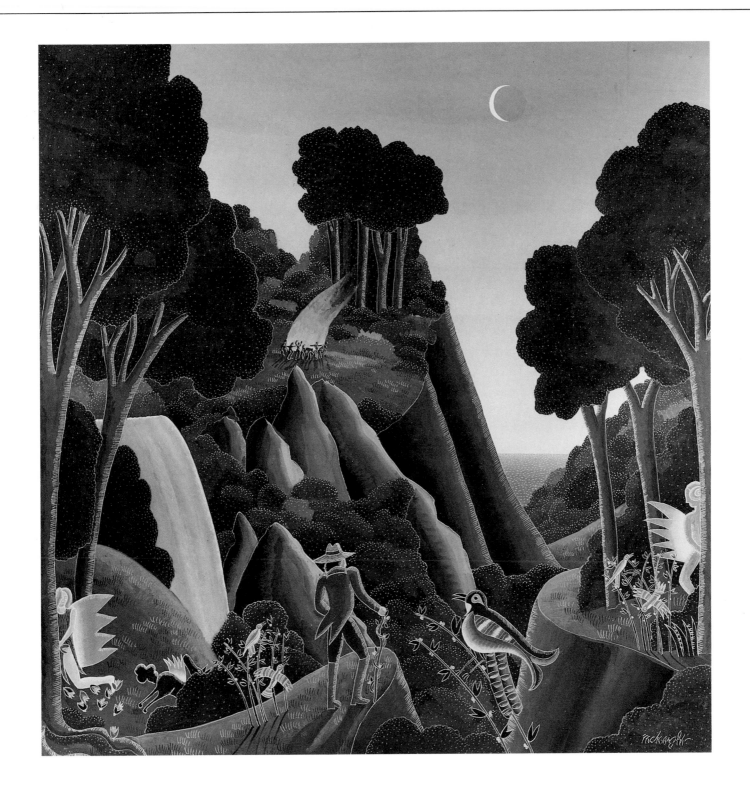

Suburban Living Room. 1981.
Casein on canvas,
24 × 26″. Collection
Mr. Michael Cohen,
Manhattan Beach, California

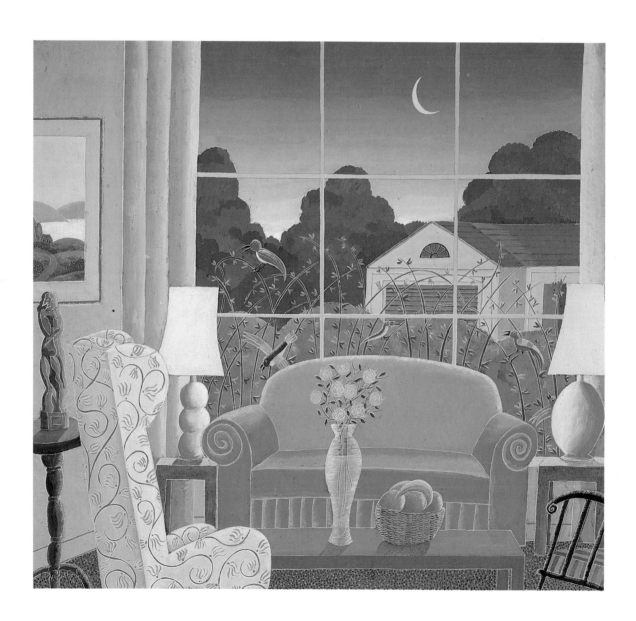

INFLUENCES

Every artist has two backgrounds that make his work what it is. His outward circumstances—his geographical place on earth, his parents, class, society, the economic system he lives under, his travels, and even the way he looks—is the more obvious one. But his interior background—the intellectual interests and influences that form his thinking, the luck and destiny he does or does not enjoy, the art he responds to, his temperament, the things and activities he instinctively loves and loathes—is no less important. What follows here is an attempt to integrate the two, to sketch a brief story of my life that shows both sides of the coin.

I grew up the eldest child in a Midwestern middle-class family that was early transplanted to the suburbs primarily of Montreal, Washington, D.C., and New York. Sports did not interest me, although I would walk for hours as long as there was a goal in mind. I was shy and introverted, a dreamer, but could cover that up with a *bonhomie* sometimes felt. I had few but intense friendships with boys who were more outgoing than I. Later I discovered girls—preferably mysterious, quiet, almost bewitched ones.

The world was "out there." It penetrated the tract house when my father came home from work with tales of corporate wars, or more interestingly when he returned from one of his frequent foreign business trips with a present of postage stamps, which I collected then. He took eight-millimeter movies, and I remember the combination of boredom and excitement as we waited through the twentieth viewing of an air passage over the endlessly snowbound Aleutians for the much more exciting reel of Oriental temples and beggars.

The world of art, of the coming and going of famous people, and of grand events, was far away. I caught a glimpse of it each week in the issue of *Life* magazine my mother would buy on Friday night with the weekend groceries. Here was Marc Chagall, there was General MacArthur, making art and war, respectively. A ball in Venice attended by Elizabeth Taylor was as exotic to me as the Fourth Crusade. I devoured an eclectic mixture of Richard Halliburton's *Book of Marvels*, histories of Greece and Rome, and biographies of Brazilian emperors by V. Sackville-West, along with the more traditional *Treasure Island*. With junior high school my purview

Opposite
Gothic Revival. 1982.
Casein on canvas,
40 × 48″. Collection
Mr. Alan R. Gronsbell,
New York

Sacred and Profane Love.
1979. Casein on canvas, 36 × 40″.
Collection the artist

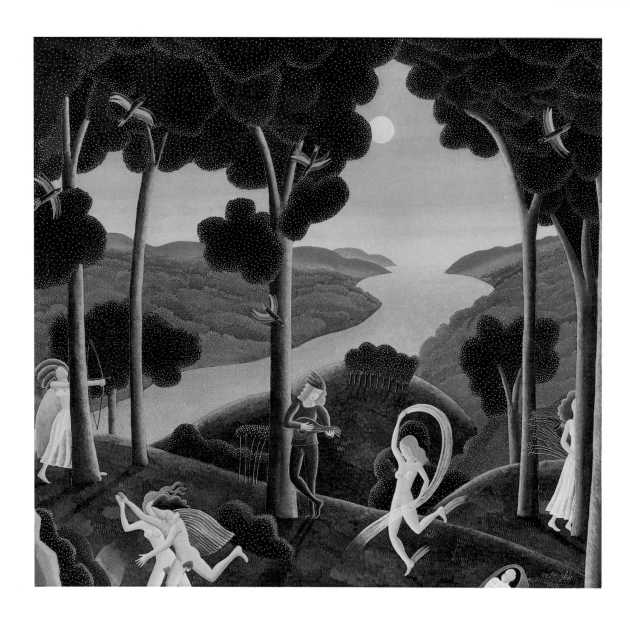

extended to Washington, D.C. The National Gallery, the Corcoran Gallery, and the Phillips Collection became my Saturday haunts. Even now the paintings in these collections remain to my mind the quintessential ones—those most intensely seen.

I also came to spend many Saturdays in the antiquarian bookshop of a Dickensian Englishman who specialized in incunabula (books printed before 1500) and first editions of early music by the likes of Haydn and Mozart. Here in an atmosphere smelling of old leather and forgotten texts, I pored over the medieval woodcuts of the *Nuremburg Chronicle*, or the more elegant examples in the 1499 *Hypnerotomachia Poliphili* from Venice—still one of my favorite books. Holding a volume that had survived half a millennium was heaven to me. A life-size Victorian wooden statue of Mephistopheles presided over the glass cabinets of the shop. An inscription on its base quoted Goethe: "I sing her a merry song, the better to lead her astray."

It was about this time, age fourteen or so, that my mother gave me a set of oils and I began to paint. My first canvas depicted a medieval castle on a snowy hill, a subject I am still trying to perfect. During these first years I read everything I could about the techniques of the old masters. One day I would be using the fat- and varnish-loaded brush of Titian and Rubens, the

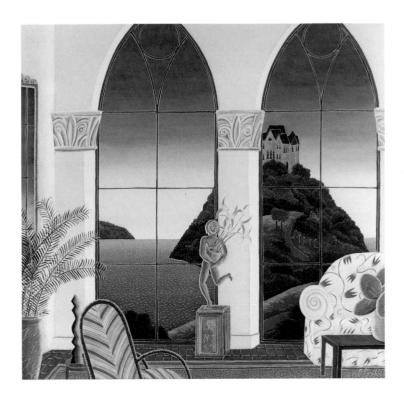

next the glazes of Van Eyck. My enthusiasm ranged over the whole history of art, from Egypt to Rothko and Guston. Of art writers, Bernard Berenson was my favorite. I soaked up everything available of his, possibly because he wrote better than the others. (I did not realize how embedded in my thinking were his ideas of, for example, tactile values and the difference between decoration and illustration until I reread him recently.) He became an idol of mine. His palatial villa in Settignano near Florence, filled with old masters and a huge library and sur-

Opposite
Lloyd Neck. 1978.
Casein on canvas,
24 × 26″.
Private collection

Easthampton. 1981. Casein
on canvas, 24 × 26″.
Private collection,
Riverdale, New York

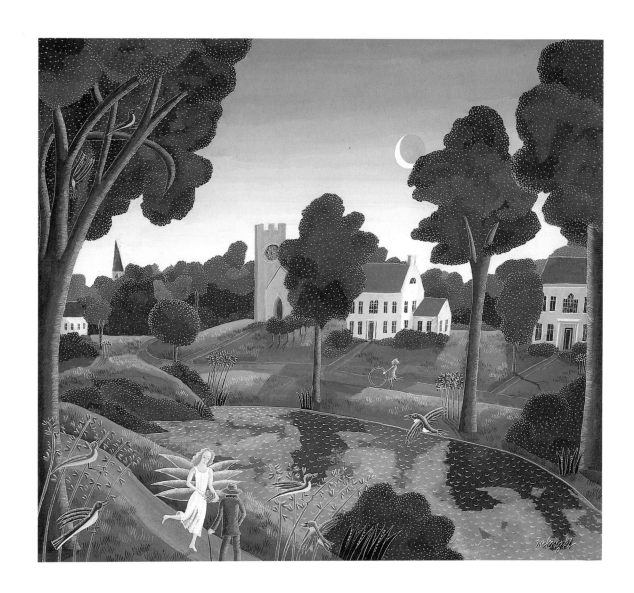

rounded by statues and gardens, became my ideal paradise.

While visiting an aunt and uncle who had a house near Bridgehampton on Long Island, I met Alexey Brodovitch, at the time art director of *Harper's Bazaar*, and now, after his death and immortalization in the film *Funny Face*, something of a legend. He lived in a large wooden house furnished in primary Matisse colors—a blue couch, a yellow floor, a cupboard filled with green Venetian glass. He, who had been an intimate of the legendary names—Miró, Dali, and Picasso during his days in France (I read the personal inscriptions under framed drawings), looked at my work and told me, "You've got it. You must continue. You must go to Paris and look at everything." We discussed our mutual love for the Neo-Romantics, Bérard, Eugene Berman, and Leonid, who also were friends of his.

Before the last year of high school, my parents moved to Long Island. It proved to be a traumatic wrenching of the closely knit web of friendships that adolescents build. Improbably, I found solace in reading Addison and Steele's *The Spectator* and fusty memoirs of English divines—all I could afford of the eighteenth century in the original at the time. As I drove around the back roads of the North Shore looking for the Great Gatsby, I wondered whose

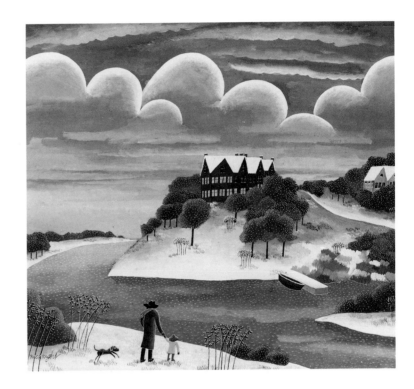

lives were illuminated by those lights in mansions half obscured by encircling parks.

The high point that year was the purchase (for thirty-five dollars) of a damaged, blackened canvas from the lumber room of the estate of the exiled King Zog of Albania—a seventeenth-century Rosa di Tivoli, so an expert guessed. Whatever it was, it was a talisman of the past. The real thing, an old master, was in my possession at last.

College at Wesleyan University in Middletown, Connecticut, became a transition phase to

Opposite
Solitaire. 1983. Casein
on canvas, 28 × 30″.
Collection Renate McKnight,
New York

Matisse Gallery. 1982.
Silkscreen, 24 × 27″

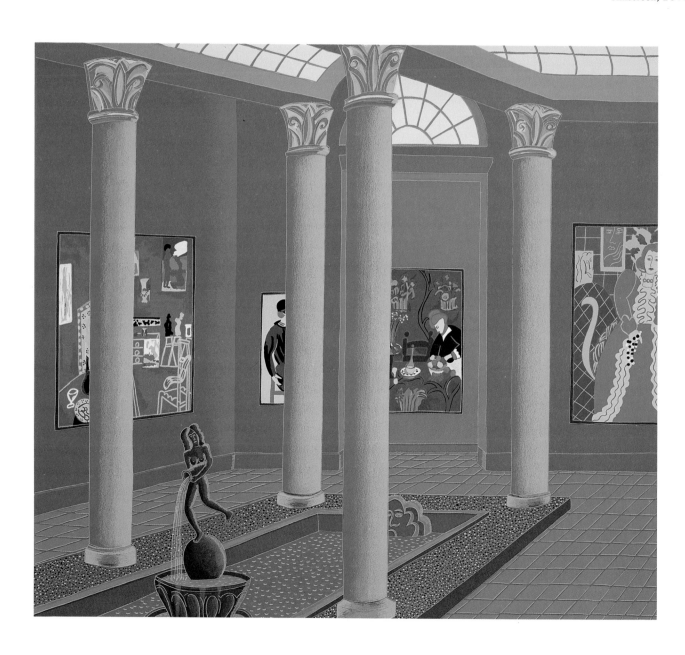

Overleaf left
Ile de la Cité. 1982.
Casein on canvas,
28 × 30″. Collection
Mr. and Mrs. Richard K. MacWilliams,
Chappaqua, New York

Overleaf right
Irish Castle. 1981.
Silkscreen, 24⅞ × 27″

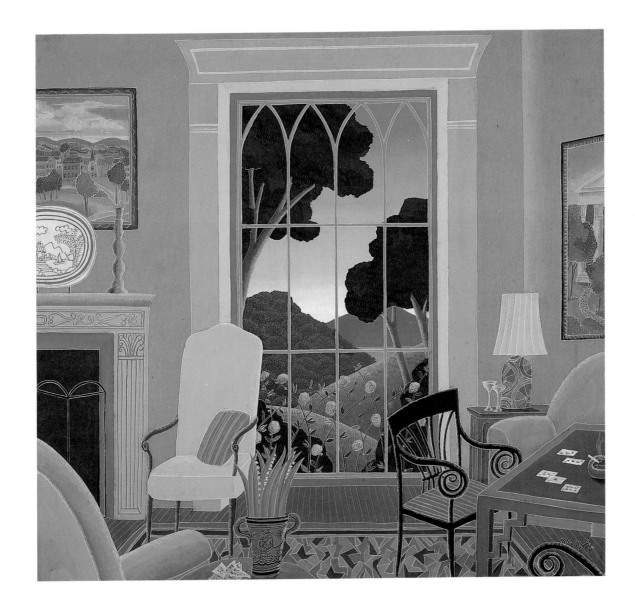

the big world. Here I met professors who had at least, in one way or another, been in contact with the world I strived to enter.

Of course I painted, but since there were only five art majors, the instruction was highly individualized. In addition, my painting professor, articulate and savvy and new on the job, was not entirely convinced about the validity of painting as a contemporary art form. This probably left more room for the eccentric, which was my path in any case.

Instead of taking advantage of the best minds at Wesleyan, such as Norman O. Brown, I spent most of my time browsing in the byways, developing a lifelong taste for the recherché sensibilities of Sacheverell and Osbert Sitwell, the poetry of their sister, Edith, the memoirs of Casanova, and the music of Satie. Although I took one tutorial on aesthetics with John Cage and a philosophy professor, all I remember was a comment Cage made as he entered the college chapel for a speech by the foreign minister of Kenya. It was winter and the steam pipes were knocking. Cage said, as he cupped his ear, "Ah, African drums."

Two buildings at Wesleyan molded me as much as the teachers—Honors College, a Greek Revival mansion of temple-like style and proportions and exquisite detail, built entirely of wood, painted white; and the Davison Art Cen-

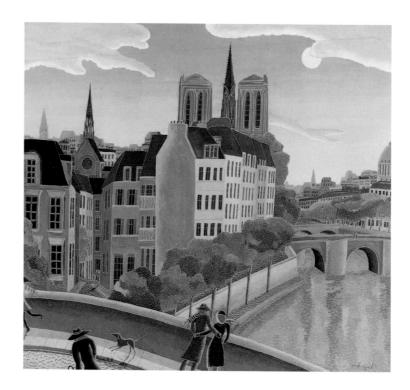

tre, a New England version of a pink Pompeian villa with cost-saving painted *trompe l'oeil* (instead of stone) statues in its outdoor sculpture niches, and with neoclassic furniture and painted murals inside. These buildings, both from the earlier years of the nineteenth century, represent to me still what the ideal living space should be—a classicism modified by illusion and central heating.

In my junior year I managed to get to Paris, ostensibly to study French for a career in art

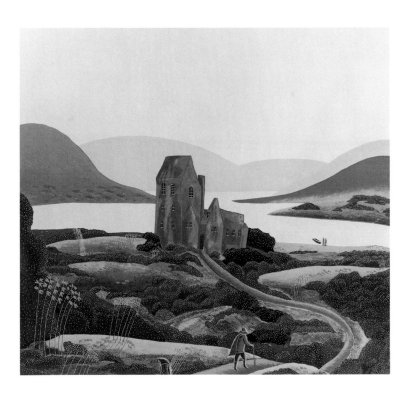

history. My first sight of Europe after a romance-filled passage on the old *Queen Elizabeth* was of the lateen sails of fishing boats and ancient dockside buildings of Cherbourg from the liner's high decks—a magic moment to be surpassed some hours later when I piled into a taxi outside the Gare Saint-Lazare in Paris. I was Fitzgerald and Hemingway to the tune of Gershwin. No matter that I had sprained my ankle running for the boat train.

I stayed that year with a White Russian family in Passy. The wife, a Georgian princess, and the husband, a former page in the czar's court at St. Petersburg, argued terrifically at the dinner table as to who was the most noble. She had a title and he had only an uncle who had been a Balkan king. They lived in diminished circumstances, but with a trace of splendor shed by a few good eighteenth-century pieces: a marvel of rococo marquetry that had been the Queen of Portugal's desk and a chair (which still appears from time to time in my work) that had reputedly belonged to Marie Antoinette. After a year I was treated almost as their son and heir. Assuming the airs and position to which I was not entitled came as second nature to me, as did the rather different pose of a bohemian in the cafés of the *Quartier Latin*, where I moonlighted a student's life.

For Easter that year I journeyed with an English friend to the East Anglian estate of his grandmother. In the bedroom I was assigned to hung a pastel portrait of our hostess as a girl of sixteen by John Singer Sargent, and the bookcases were filled with well-thumbed and annotated sets of Freud and Nietzsche. In the rest of the Elizabethan hall was a collection of art from the Renaissance to blue-period Picasso and Henry Moore. Dinner conversation was inside gossip about cabinet ministers and lords, all mysteriously identified with unexplained

nicknames. I was incandescent with suppressed excitement and snobbery as I thought how far from the suburbs I had come.

Upon my return for my final year at Wesleyan, which now appeared cloistered indeed after Paris, I became "avant-garde," painting words and letters lifted from Ionesco plays, and, since it was during the early days of Pop Art, a cigarette pack or two. That was enough to be refused admission to the Yale School of Fine Arts, which didn't think I was serious enough to benefit from its instruction.

So I quickly applied and gained admission to Columbia. The most important result of this action was that it brought me to live in Manhattan, where I have resided most of the time since. It also led me to study art history at Columbia's graduate school. Except for Meyer Schapiro, the professors with whom I came into contact there possessed a trade-school mentality, their mission to turn out museum curators and more professors. I was still imbued with the mandarin style favored at Wesleyan and polished to a glow in France, and my interest wavered. I began to spend less and less time in class and more time painting until finally I ceased attending altogether.

A job as a file clerk at *Time* magazine followed. This was succeeded by many different upwardly mobile tasks there over a period of more than seven years, a life of increasing semi-indolence and ease that gradually dried up my painting completely as I applied my energies to advertising copy. I dabbled, but worthwhile art is rarely created during spare time.

At *Time* I began to see how men lived in the twentieth century when they were not in their bedroom suburbs or academic preserves. Some enjoyed luxury—fine restaurants, first-class travel, and the brushing of shoulders with the powerful and famous—but they had a high price to pay in rigid pecking orders, competition for status, and, except at the very top, lifelong subservience to a boss higher up on the ladder. The towers of Manhattan gave, but they also demanded sacrifice.

A two-year hiatus in Korea, courtesy of a U.S. Army draft board, not only spared me from Vietnam but showed me a world that could not have been more different from New York. I spent the "summer of love" and the year after that in a supply depot incongruously plunked down like an American suburb in the middle of rice fields along the Naktong River. Hiring a local rice farmer to help me during his inactive months, I made huge pointillist paintings on local bleached muslin with imported paints. Some were abstract, giant swirls and jags; others were portions of anatomy, such as a torso blown up to five by six feet. By candlelight I read

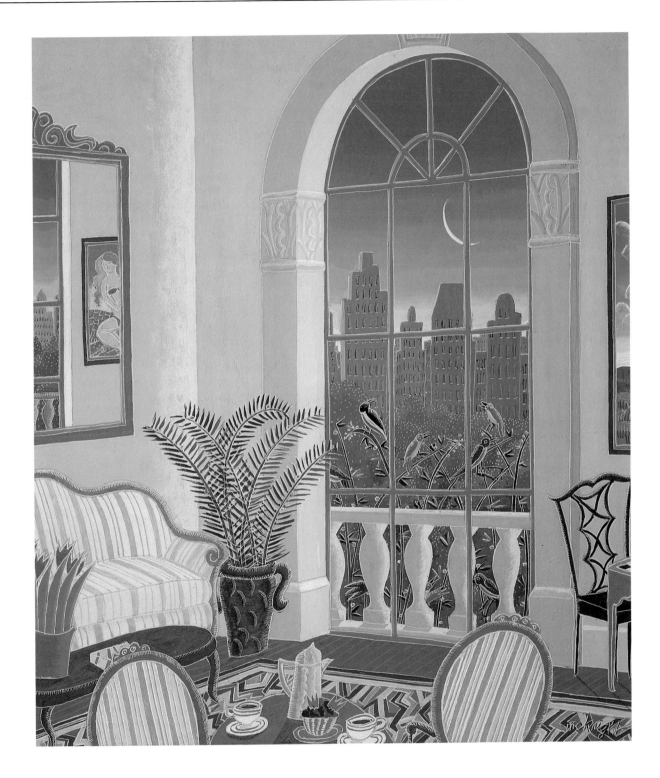

Preceding page
Afternoon Tea. 1983. Casein on paper,
16 × 14″. Collection the artist

Opposite
Schloss Remseck. 1979.
Casein on canvas,
11 × 14″. Private collection

Mykonos Windmills. 1984.
Casein on paper, 16 × 18″.
Collection the artist

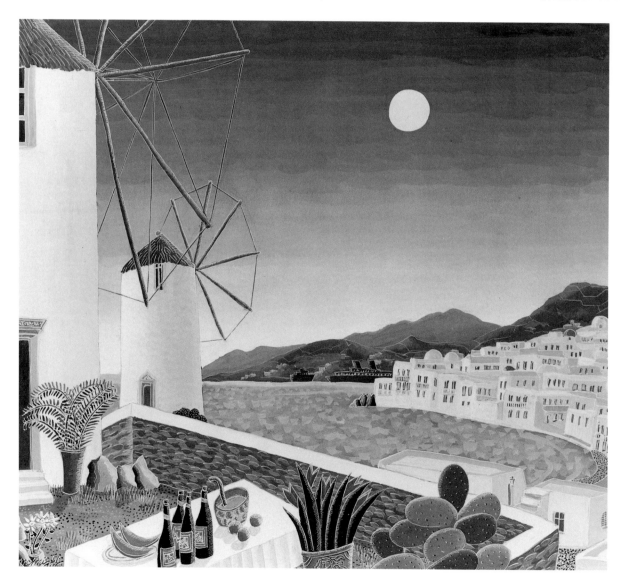

Artforum in my rented room in town, but had to be back inside the compound's gates by midnight.

After my return to civilian life and *Time* I took on the additional job of a nonpaid weekly art critic for a radical New York radio station. The need to see what I reviewed forced me to take an overall look at everything that was going on in the art world in 1969 and 1970. That was the year the Museum of Modern Art mounted an exhibition called Information Art. This conceptual, disembodied stuff made me realize that the historical progressionist theory of art had collapsed in a heap of typewritten photostats. Logically, there was nothing left to do, and so all was possible, anything was valid. The gnomic images I harbored in the most secret recesses of my imagination could come forth. I could ring in the old.

But in an age of overwhelming cinema, video, and mass media images, I could still not intellectually justify creating handmade images. In a conversation with the artist Sylvia Sleigh about this subject, she observed simply that people still lived in rooms that had walls. For walls, they needed pictures.

A trip to Greece in the same year moved me closer to the realization that my days in the corporate world had to be numbered. Two weeks in the heady atmosphere of an island in

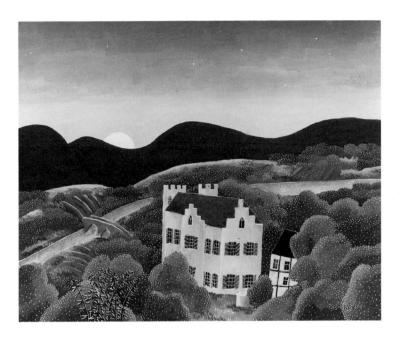

the Aegean, surrounded by people who spent entire summers there, made me more determined than ever to break away. Upon my return I retreated every day after work into my small East Side apartment and painted as if my life depended upon it.

Sometime later, a year after leaving *Time*, my decision bore fruit. A first show took place in Washington, D.C. While it was not the financial and critical success that all debutant artists expect, it sold enough work to keep me going a little longer. Not long enough, however, because I soon became desperate for funds. After my next-to-last bank withdrawal, I returned to my apartment and thought as I stared bleakly out

the window, "The name of the next tanker that sails up the East River will be an omen for me. Do I continue painting full-time, or do I return to publishing?" In five minutes a Greek tanker appeared. Its name was the *Phoenix*. The binoculars trembled in my hands.

A week later a check arrived, and soon after that an agent arranged my first show in Europe, near Stuttgart. The dealer was an old count who dealt in art almost as a hobby. He told me, "Paint small. My friends have had their walls full for several hundred years. That's all they have room for." My work sold well there, and for some years afterward, all my bread-and-butter and rent money came from Germany. These paintings were composed with a very brown palette, which particularly appealed to the Germans.

For a while, now that I had an income, however precarious, I began to follow the paths of least resistance. While I worked hard, I played hard, too. The cold months I spent in Manhattan. During the day I painted, and then spent half the night carousing in bars and discos. The warm months saw me traveling to Greece with blank canvases rolled up under my arm. Here I painted less assiduously, for only half the day. The other half I sunbathed and chased the nymphs who had fled the foggy north for these clearer shores. I was doing what I wanted, but still I was dissatisfied. "There must be more to life," I thought.

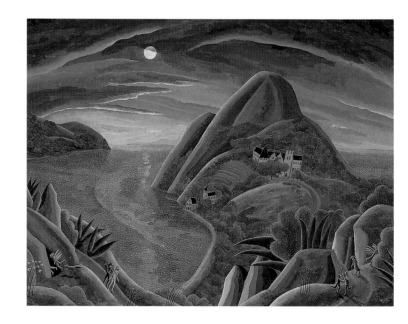

On a brief trip to New Mexico, at the Taos Pueblo, at nine on a crisp blue morning I began to quake and feel energy pulsing up and down my spine. As tears came to my eyes, a kind of spiritual orgasm swept over me. After a minute or two it stopped, but the residue it left impelled me into a study of the paranormal, Jungian and archetypal psychology, and the occult. How to explain it? At the same time a flawed romance gave me the impetus to retreat from the way of life to which I had become accustomed.

During this time my painting became increasingly darker as I attempted to expunge frivolity and get down to basics. Erroneously, as I see now, I equated frivolity with color. Gradually, after a year or two, the rainbow began to return

Opposite
Episodes on the
Atlantean Coast. 1977.
Acrylic on canvas,
36 × 48".
Private collection

Mykonos Terrace. 1983.
Casein on canvas, 28 × 30".
Collection Mr. Ernst Hödl,
Scheibbs, Austria

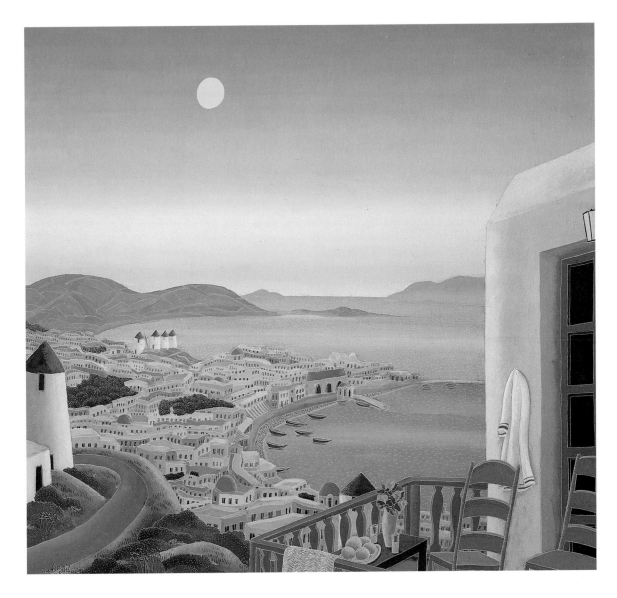

again when I painted a nymph in a red room, and slowly I too began to reappear in the world.

One summer I spent some days on the ancient island city of Delos, the sacred birthplace of Apollo and Artemis. Here I had a prophetic dream. I was passed the torch of art by an artist friend (who was to die a couple of years later).

My personal renaissance was completed when I met my wife Renate (which means rebirth) on the nearby island of Mykonos. I saw her first one morning at a café table eating breakfast. She tapped her foot, impatiently awaiting the arrival of someone else. After our first dinner together, we passed the whole night wandering the white moonlit labyrinth of Mykonos. I said to her, "I think we will be with each other forever." She agreed. She brought to my life a kind of romantic solidity that came out of a childhood picking flowers in the meadows surrounding a walled Austrian town and a girlhood escaping from a strict convent school in Vienna. Her arrival seemed to coincide with an enriching of my work, as I continued to strive to get at the heart of what obsesses me.

Since our meeting we have roamed the world together, from Egypt to Mexico, from Morocco to Capri, collecting the scuff marks but also savoring the delights of voyaging. Travel is heightened life in the same way that opera, or reading, or music is. It is not always pleasant, but

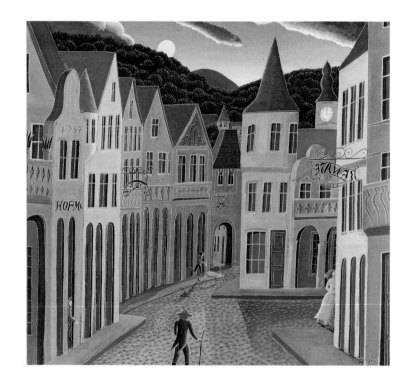

it jogs the mind out of its ruts. For me, it is as real as the life of a man who goes to an office or factory every day.

Painting my dreams has enabled me to live them. Not a day passes that I do not thank my stars that I can do this, but it was not luck that brought it about. Luck exists only for people who meet it once. It comes so regularly to those who do not court it that it can no longer be called by that name.

Opposite
Austrian Village. 1981.
Casein on canvas, 26 × 28″.
Private collection

Gardens of Augustus, Capri. 1982.
Casein on canvas, 24 × 26″.
Private collection,
Riverdale, New York

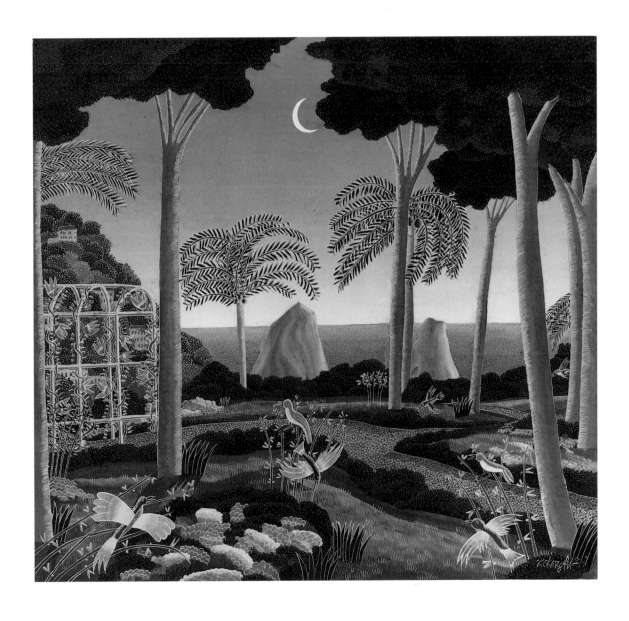

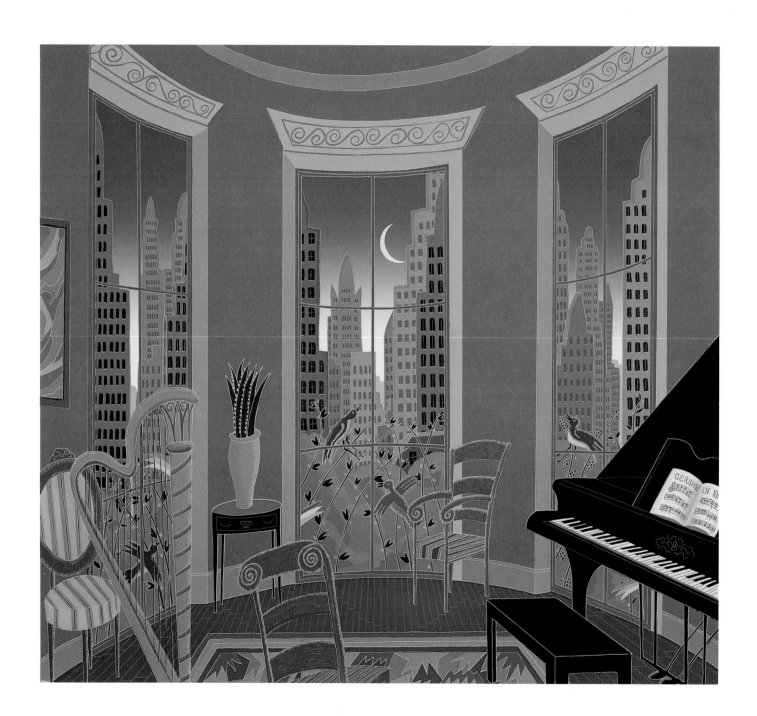

PLACES AND IDEAS

Although I am an American, I do not feel completely at home here. When I am in New York, I yearn for Europe. I collect books about travel and eat in Little Italy, I drink ouzo and listen to bouzouki on the radio. When I am in Europe, I am eager to return to my round of work and everyday pleasures, to Dorito chips and Diet Dr. Pepper, to bookstores and the variety of Manhattan street life. Perhaps because as a child I moved so much, there is no one place of which I can say, "Here is where I come from." My memories of childhood take place on suburban streets in suburban houses that could be almost anywhere.

There are two places in America, however, where I seem to fit better than elsewhere: Manhattan and New England. Manhattan has been my actual home for more than twenty years. I have lived in New England only during my college days, but, with its wooded valleys, white towns, and broad village greens, it has always been my ideal rural landscape. There are dark myths in New England that contrast with the lights of Manhattan. There are also other New Englands that attract me—opulent nineteenth-century summer resorts like Newport and the Berkshires, and university towns, like Middletown and Amherst, that look as if the old-fashioned Athenian virtues were still in residence.

There is something ancient in New England, something unknown and maybe unknowable, but there is also the very familiar. To my mind, the seasons it passes through, and the weather that passes over it, are the most typical. A palm tree, a desert, or an alpine meadow will always be exotic in a way that nothing in New England can be.

New York, on the other hand, is a stew of the exotic and the familiar. Although it is home, I still feel as if I'm passing through. I know it thoroughly, but I continually find new neighborhoods that have grown up since my last visit. As in Venice, the view from my window stretches for miles but everything in it is manmade except for the sea and the atmosphere. An artist friend once looked out of my midtown window and said, "Your landscape, your trees are these skyscrapers. Your leaves are these twinkling windows. No wonder you paint rooms!" In other places the leaves change color, the flowers bloom and wither. In Manhattan, instead, new prints and paintings appear in gal-

leries; books bloom in bookshops; fashions change complexion and shape on the streets and in the fantasies of display windows; movie marquees are relettered. Night is day and strawberries are in season in January. Nature exists here in the supporting role.

Living in Manhattan is probably the real source of all the interiors I paint. Everything in New York encloses something else. Like Chinese boxes, a square midtown block encloses a tenement and a luxury high-rise; the high-rise contains an office, a drug den, and an apartment. The apartment contains rooms: an Indian motif, perhaps, in the bedroom, but the living room is French neoclassic. In that living room are paintings, and books by Michel Tournier, Adrian Stokes, and Derek Walcott. In turn, these books and paintings contain different worlds. It is a seamless web of eclecticism.

The genesis of an interior painting begins usually with a very slight theme, be it the color red, a Gothic arch, or a couch with a certain pattern. Since the interiors are *capricci* in the sense that one element engenders another in the composition, they often are arbitrarily titled after the fact—to match something of the feeling of the invented place with a real name. The paintings of other artists in my works (mostly by Matisse, Picasso, and Léger, because they are easy to copy and fit stylistically) function as windows to the world of art, as the other windows look out at

Manhattan, the world of reality.

New York, as the French historian Fernand Braudel has put it, is the world city of today, as London was in the nineteenth century, Amsterdam in the seventeenth, or Rome in its time. It is the place where everything comes together, but where everything is thrown out again to transform the world.

The New York I paint is centered on the towers, the far vistas, and the views to and from Central Park, but the New York I live in is further down, on the street, where it gets dark earlier in the afternoon. There my sport is to haunt bookstores looking for rare but not expensive volumes by authors that nobody reads, and about subjects that are not fashionable. Having cornered my quarry, as I pounce I feel the same rush of excitement that accompanies the first sketch of a new idea. Apart from painting and traveling, this is my greatest passion. I have heard that Broadway is an old Indian hunting trail, and it still serves that purpose for me as I pad it on my way to my own hunting grounds at, for example, the Strand on Twelfth Street.

To reflect upon New York and life there, distance is essential. For that, I go to Mykonos, a Greek Aegean island in the Cyclades where I have spent a portion of each summer for the past ten years. This is the spare part of the Mediterranean, with none of the oleander-covered ruins and indolence of its Italian and French coasts.

Music in Manhattan. 1982.
Silkscreen, 24 × 26¼"

Chelsea Department Store. 1982.
Casein on canvas, 28 × 30".
Private collection, New York

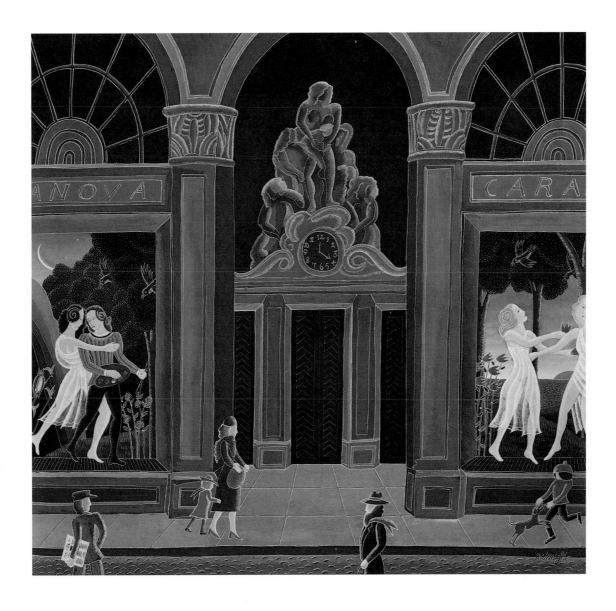

Mykonos Street. 1984.
Casein on paper, 16 × 18″.
Collection the artist

Page 44
Boboli Gardens, Florence.
1980. Casein on canvas,
24 × 28″. Private collection,
Boston

Page 45
Rialto by Gondola. 1983.
Casein on paper, 14 × 16″.
Collection the artist

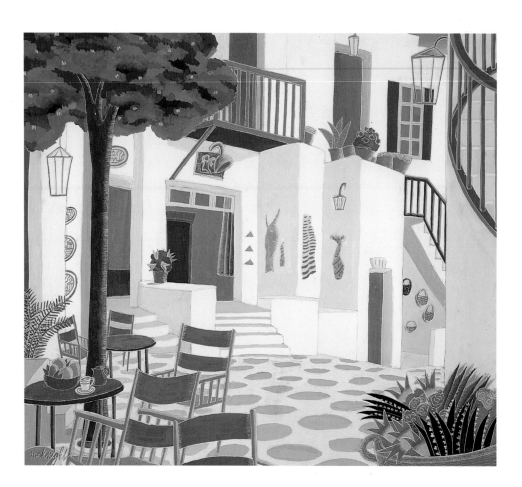

Elia Beach, Mykonos. 1984.
Casein on paper, 16 × 18″.
Collection the artist

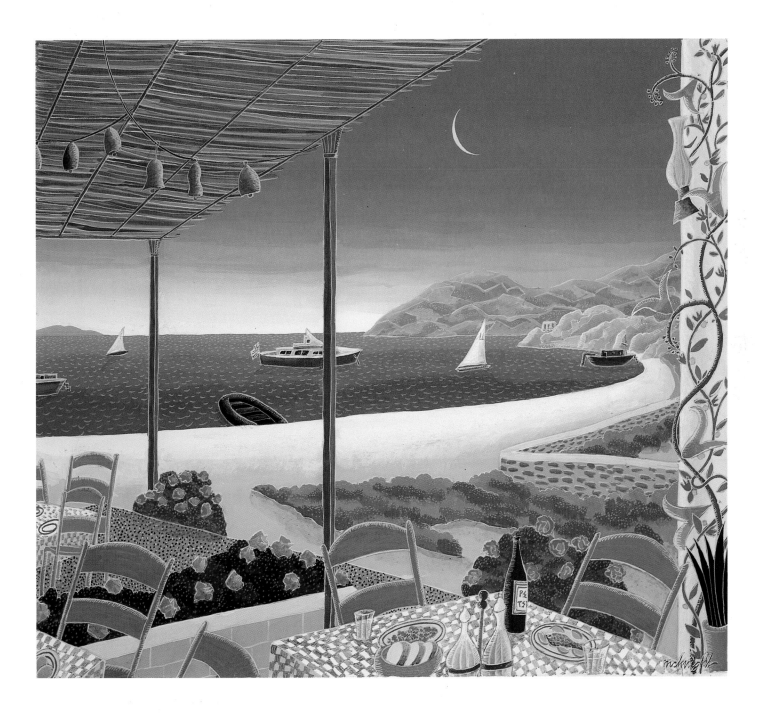

Here all is bleached white and unclouded azure blue. The hills are the color of camels and strewn with rocks and boulders. What grows is low to the ground and smells of thyme and oregano. Strong trade winds blow and make the windmills creak for days; the town is built like a labyrinth to baffle the wind and to protect it from what the natives call the *meltemi*.

On Mykonos we rent a jeep and a room on a beach far from town. Here at dusk, after the bathers go, only a few stragglers sit in the waterside taverna, and the most exciting event is to await the moonrise over a nearby hill. During the day I lie on the nude beach and admire the bodies of all Europe frolicking. At night I either read something extraneous to the present, like Balzac, by candlelight, or with my wife driving, take the jeep to town for an evening in the fleshpots around the harbor. Everybody dresses a role here, framing expensively bronzed skin with bright colors, draping bodies in picturesque attitudes over café tables, and filling the courtyard restaurants and harborside cafés with clatter and bustle. Gossip is king—the small change of the gods, someone once said. Gods themselves are only a twenty-minute ride away, on Delos. Henry Miller said that in Greece the elements are most themselves—water is wetter, air is airier. Nowhere is that more true than Mykonos. It is necessary to leave (after a while

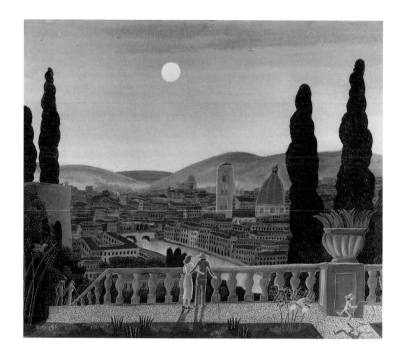

lotus-eating can get boring), but it is also necessary to go back.

Another place as necessary to return to is Italy, the land of nostalgia, but, unlike Giorgio de Chirico, and perhaps because I am not Italian, I do not see it as menacing. To me it represents what the ideal civilization would look like if every day were sunny, every night moonlit, and if politics and economics were not factors in the quality of life. Not only does it have its body-loving aspect of pasta, arugula salads, lemons, and flowers, but it has its soul-satisfying artifacts like Baroque churches encasing classical temples

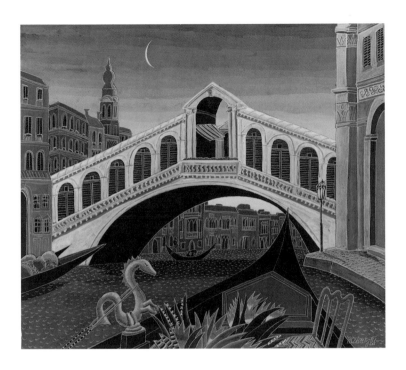

operatic view of life. My favorite landscape is in the south—the cliff-hanging towns of the Amalfi Drive, Sorrento, Capri, and Taormina in Sicily—but my favorite city is in the north.

For me there are two Venices. One has its heart in a carnival scene written by Goldoni from the memoirs of Casanova, with music by Paisiello, long shots by Canaletto, and close-ups from Longhi. Around this heart are grouped vignettes—flashbacks to the galleys of Lepanto; to the relief of Greek cities in the Morea with celebrations in San Marco; to the return of Marco Polo, and the arrival in town of Titian.

The other Venice is the modern, decaying city that so suddenly came into view one bright winter's afternoon when I stepped out of its railway station onto the Grand Canal. My first night was spent in antique splendor in a room in the Gritti Hotel, and breakfast was served against a backdrop of Santa Maria del Salute. If it was not a dream, it was a state of reality heightened by art to something approaching one.

Robert Harbison, in his book *Eccentric Spaces*, maintained that Venice, like New York, is a stage set. The populace is so densely packed in its public places that a constantly evolving drama takes place as actors group and regroup, take on starring roles, and walk away—a play that ends only for a few quiet hours at night. Living in either is living in a work of art, but Venice is the

and statues of Roman emperors in Renaissance squares. Even the way it has been responded to by expatriates and travelers like Goethe, Hawthorne, Thomas Cole, Ruskin, and, more recently, Norman Douglas and Harold Acton intrigues me. When I can find them, novels with Italian settings by such now-obscure authors as Cecil Roberts and F. Marion Crawford are my favorite bedtime stories.

When I finally traveled to Italy myself I was not disappointed. Although I do not mesh well with the chaotic, frenzied side of the Italian temperament, I do connect with its dramatic,

Opposite
Cafe Winkler, Salzburg. 1980.
Casein on canvas,
28 × 30″. Private collection,
Riverdale, New York

Carnival. 1981. Casein on
canvas, 24 × 26″. Private
collection, New York

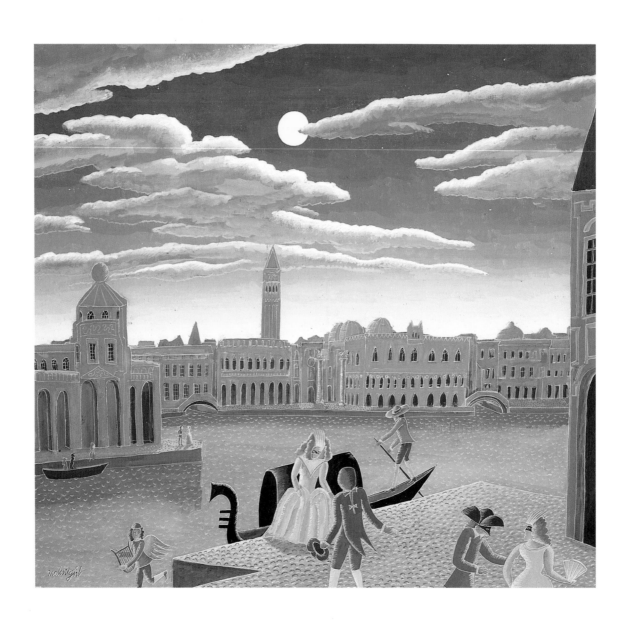

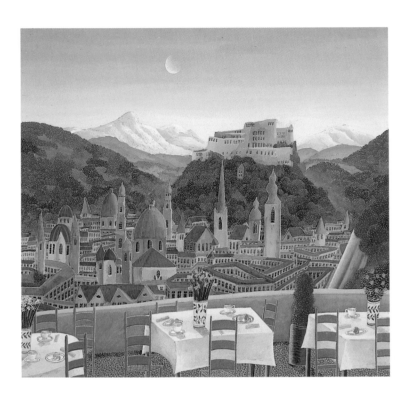

pine forests. The Cafe Winkler on top of the Monchsberg has what is perhaps one of the most fulfilling views in all of Europe, a perfect mixture of domes and steeples, fortresses and hills, packed into a tight valley for maximum effect. The body that catches the sun on its skin next to the Mediterranean here eats and drinks the warmth into its belly instead.

The paragon of northern cities for me, however, is Paris, the city of a year of my youth. Even now I find Paris hard to paint, because it was a place of such intensities of boredom, happiness, despair, and longing. It holds perhaps more than any other place the origins of my formation as an artist and a man. Certain memories from the Paris of twenty years ago—listening to a Paganini-like violinist in the Place Vendôme; watching children play and girls walk by in the Luxembourg Gardens; being exquisitely bored on a lazy Sunday at the Grand Guignol; or inspecting the *filles de joie* in Les Halles on a spring evening—possess an intensity that more recent memories cannot evoke because they are not the first. Even the furniture in the house where I lived is still my ideal—from the late eighteenth and early nineteenth centuries and neoclassic in style.

old master, New York not yet varnished.

Since that first short visit I cannot let a year pass without another, and each occasion adds memorable sights and meals and gondola rides. I prefer the architecture and painting of Florence, the climate of Sicily, and the views of Capri, but Venice has the charisma of an old mistress who, though discarded, is still loved in a fashion, and so must be kept up with even in her decline.

The northern Faustian side of the Alps for me begins in Salzburg, whose spirit is a *café melange* of sunny Italian Baroque and the Gothic of the

In between the pages of these real places lie the imaginary ones. Some might say that they are dimly filtered memories from the Atlantic continent that disappeared beneath the waves one

fiery night ten thousand years ago; others that they are pastiches of memories and fantasies of Egypt, Greece, and Rome, the Channel coasts of England and France, and the forests behind them. They are nowhere and everywhere. They are constructed of elemental forms—hidden valleys, wind-blown seacoasts, and coves intermingled with groves and rocks. Grafted onto nature is a path or road or perching place, and on that road is a traveler. Ahead of the traveling wanderer is a goal—a lighthouse, littoral, nymph, or shining horizon. If a city, it is half-mirage.

It has happened sometimes that what I have imagined I have later discovered in real life. Recently, for example, I spent some days in Marrakech in Morocco, a "rose red city half as old as time." Once our horse-drawn *calèche* had penetrated its Moorish-gated mud walls, we were in a time warp to the Middle Ages. Men went about their business in hooded cowls like Capuchin monks, women were veiled; innumerable stall shops sold leather bindings, oranges piled on green leaves, and spices, like a fifteenth-century Paris or Seville.

In my fantasy landscapes, allegories or restagings of mythical events, like the pursuit of Daphne by Apollo, sometimes take place. Reconstructions of the Laocoön sculpture group are scattered for discovery in open glades or walled gardens, or in the form of frescoes on temple precinct walls. Symbolic figures appear here suddenly as if by magic—standing still and watching, or writhing, or whizzing by, intent on their own destinies, with no other function than to amaze. This is the land where all things are possible, a dream of a golden past or future or "otherness" that can be also found in the work of Claude Lorrain, Watteau, Burne-Jones, Samuel Palmer, Albert Pinkham Ryder, even Balthus.

Just as Chagall uses Russian folklore, I use my own "folklore," the history and art of Western civilization, as material for these image dramas. I do not blindly follow tradition but borrow, recombine, and invent. For a tradition to live it must grow and renew itself with fresh visions.

It is my belief, shared by others more knowledgeable than I, that we are at the end of one Great Year and at the beginning of another. Just as the pagan world of classical antiquity was transmuted and enfolded by the Christian era, at the next mutation the Western tradition as we know it will be likewise enfolded and transformed. Like the first Christians, who adapted temple sites for churches and changed the names of statues of Apollo to Christ, so too shall we proceed.

As an artist, what I feel I must do now is to dredge down to the deepest layers, bring up the symbols and creatures that dwell there, and pre-

The Nubian. 1983. Casein
on canvas, 36 × 40″.
Collection Renate McKnight,
New York

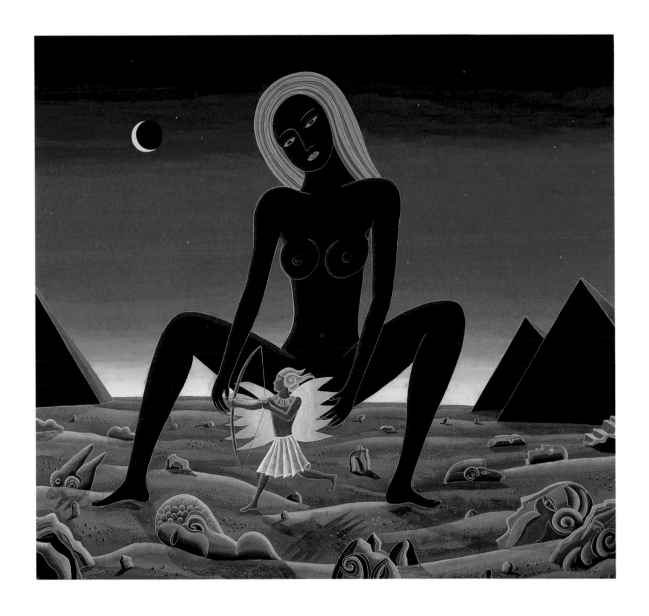

Rebirth of the Shadow. 1982.
Casein on canvas,
24 × 26″. Collection
Mr. Alan R. Gronsbell, New York

sent them in a way that will seem most personal and meaningful to me. If the images come from this deep archetypal level, and if I am capable of conveying it, their power will guide others as it has guided me. Thus a personal creation will become a universal one, and in time a new myth can be born.

The eighteenth-century Neapolitan philosopher Vico thought that civilization passed through four ages—of gods, heroes, men, and chaos. Writing and, by inference, art changed from hieroglyphics with multilevels of meaning to heroic verse, to commercial language, then to degraded, near-meaningless verbiage. Obviously, with our failing institutions and systems of belief (not to mention semiotics and deconstruction), we live in the Age of Chaos, but the image of the hieroglyphic icon may soon arise again.

For me, the very core of art is this iconic image, which is truer to spiritual than visual nature. It is the opposite of Impressionism, which is concerned with specific places and times. I look for what is timeless, of the essence, what is most characteristic of a time or place or thing. For example, I would never paint Capri in gray rainy weather because for me Capri means blue skies, warm zephyr-like breezes, and radiant moonlight. Or Manhattan is a tangled zone of trees and paths in the center called Cen-

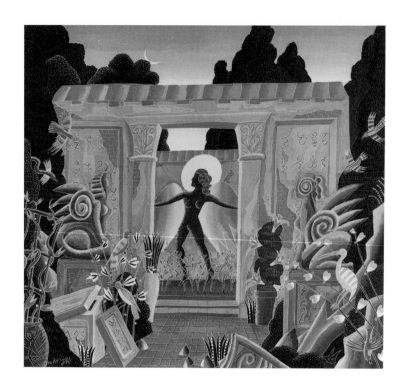

tral Park, surrounded by a lattice of straight streets that cut through forests of towers. Manhattan is not for me the anomalies—a Burger King on Ninth Avenue that looks like Indiana, or the Cloisters in Fort Tryon Park that looks like Tuscany.

On a continuum from complete abstraction to complete representation, I try to find the fine point where the ideal image resides. If a painted object is too general and abstract, it loses its

Apollo. 1982. Casein
on canvas, 28 × 30".
Private collection, New York

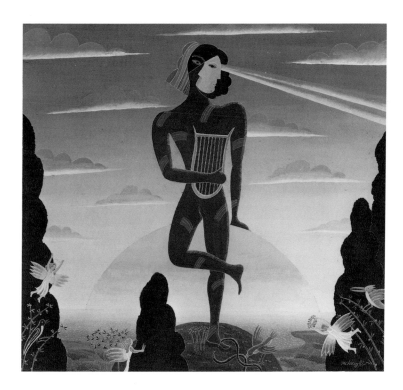

power as a specific image and runs the risk of becoming just decoration. Then it can mean anything and nothing. If it is *too* particular and representative of a specific object (like a portrait by Philip Pearlstein with all the warts or a goddess by Bouguereau with cellulite), it loses its spiritual power to represent a class of objects. Someplace in between is the ideal, say an image of Apollo that is enough like a man we can identify with, but enough *not* like a man so that

he can serve as the container of many emotions—an icon and a god, in other words.

A view of Manhattan that contains too much information about the real thing leads my viewing astray from feeling to thinking—documenting and illustrating. If a painting of Manhattan is not specific enough, on the other hand, my viewing is limited to empathy with the outer forms, for instance, the shells of the building shapes and the perforated horizon. This is not enough. In my work I aim for the point where the image of Manhattan is evoked with just enough detail to allow the viewer to feel its most essential qualities. With not enough detail the image is still-born, with too much it thuds to earth. When it has just enough it soars.

The iconic image ideally contains just the right amount of imagery to generate the optimal amount of emotion. And since emotion is also energy, there is a pragmatic justification for art that can appeal to all, even those who think it frivolous icing on the cake. But art must be directed to the beautiful and true to last. I do not agree with those who say that since we live on an overpopulated, fear-ridden globe that we must necessarily paint chaos and gloom. Raphael's serene madonnas and Botticelli's nymphs leaped forth from war zones. It is my belief that the natural man tends to sink to the earth and it is the duty of art to lift him up on the side of the angels.

57th Street Gallery. 1983.
Casein on paper, 14 × 16″.
Collection the artist

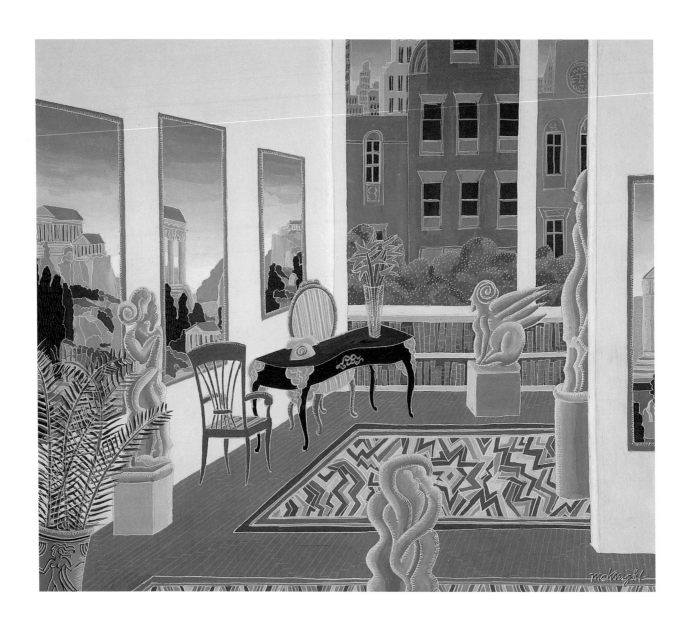

TECHNIQUE AND COMPOSITION

Why do my paintings look the way they do? There are reasons that have to do with how I paint—the technical business of putting brush to canvas—and others that touch on why and what I paint—the translation of impulse to image, of feeling to expression. The first thing you will notice about them is their size; they are small compared to much of what is being done in New York, where the tradition is to paint BIG—for museums and public gaze. I make mine for private viewing, for one or two sets of eyes, for hanging in rooms where people actually live and dream.

The next thing you will notice is the surface. It is matte or just slightly glossy because the medium for the paintings' colors is Shiva casein, a pigment in a milk- and water-based emulsion. It gives to the surface a quality that approaches quattrocento Italian fresco. Its flatness puts the texture of things in their images, not on the painting's surface. Unlike oil, which because of its varying paint thickness tends to highlight, it is also well suited to render all objects with equal weight.

The colors are saturated and glowing but have a cooler cast than oils give. The drawback of casein is that if it is applied too thickly it cracks. Therefore, if I make a mistake I usually have to scrape off the old paint before I can begin again. Casein's advantage is that unlike oils, which darken, blacken, and become transparent over the years, casein goes through all of its chemical changes within the first year or so. After that it never changes chemically. Using it takes some getting used to—for example, it dries much lighter than it looks wet, and that makes it difficult to match tones exactly. I once used acrylics, which are easier to obtain, but they have a transparency, inflexibility, and plastic feeling that I do not much like.

As ground for the paintings I stretch a linen canvas on which I apply a layer of white acrylic gesso, which I then tone down with a wash of Venetian red. For smaller pictures, I do the same thing on good rag paper. On this surface I draw with soft vine charcoal sticks. I use it like a blackboard, drawing and erasing until a composition is built up in general detail. Usually I let the charcoal sketch age for a while—sometimes new ideas turn up, or inadequacies of composition choose to reveal themselves only in time. Before painting (especially if the drawing is

complicated) I take a Polaroid picture of it so that when I paint the background and have to cover up details, I have a record of where and how to put them back in again.

The process of painting I follow is the traditional one, beginning with the sky, working from the horizon up, and then from the horizon down. A first stage of painting covers the surface with the main forms; a second adds details like dots and flecks, flowers and chairs and windowpanes; a third finishes it with the whitish ocher lines that further delineate detail and, by keeping the colors slightly separate, allow them to breathe and sing. The audience for a painting begins with one person, the artist, and expands to a greater or lesser degree depending upon the charms of technique and/or subject matter. A not-so-well painted but sunny interior will always outdraw a well-painted nightmare, for example.

Motifs for silkscreens, however, must be chosen with a large audience in mind. To sell out entire editions of prints consistently demands a certain attention to subject matter. Since there are so many variables, motifs are always chosen from among my paintings. Serigraphy (or silkscreen) is such a complicated process when one employs as many colors and screens as I do that it is simpler to have the compositional and color problems worked out first on canvas or paper. Even so, there are always more than enough technical problems to cope with.

Deciding which motifs to use is a dialogue between the artist, the publisher, and that great unknown, the public. Sometimes the publisher gives way and an esoteric (hence less commercial) but aesthetically satisfying print, like *Narcissus*, will be produced. Sometimes the publisher prevails and a sure-fire hit like *Cold Spring Harbor* is chosen. Sometimes the public fools both.

Making a silkscreen might be compared with creating a movie—you need lots of experts to produce a finished, seamless product. The artist, like the screenwriter or film director, initiates and oversees the creative process, but indispensable to his vision are the screen cutters, color mixers, proofers, and printers, each of whom reigns supreme in his particular stage of the work.

Here is how a silkscreen comes into being. After the master image is finished, it is analyzed for color and broken down to the fewest possible. Since some silkscreen inks are opaque and others are transparent in various degrees, the forty or so basic and indispensable colors can be increased with overlaps and shadings. For each of the basic colors a separate drawing is painted by hand on acetate. These drawings are then made into stencils, which, when mounted on silkscreens, can be used for printing. The ink is screened through the silk (so that it can be applied smoothly) with a squeegee, each time by

Cold Spring Harbor. 1984.
Silkscreen, 26 × 28″

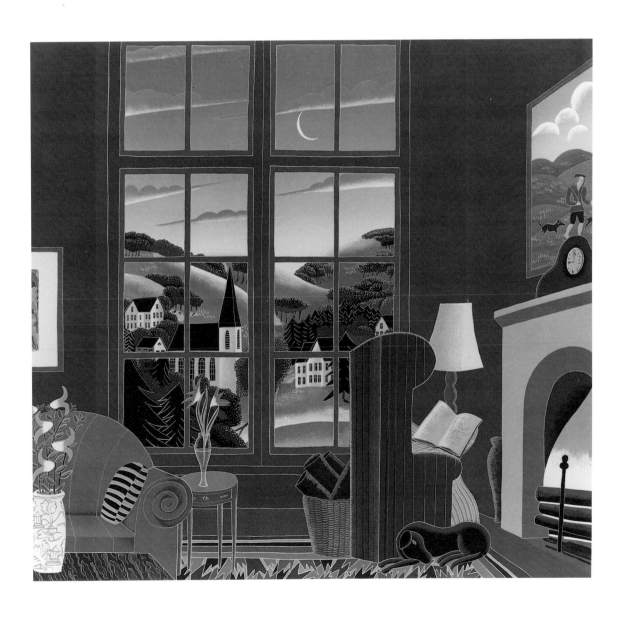

hand. Thus, a forty-color silkscreen would go through the press forty times.

At least one and sometimes two proofings are made of all the colors before approval is given for the final edition. All the glitches and technical problems must be worked out first. Each time the print goes through the press, it must be precisely aligned—a hair's breadth off for any one of the forty or so colors and the print is ruined and has to be thrown away. Even the weather affects the job. A damp day will expand paper enough to throw the registration out of whack. New York's humid summers cause printers heartaches. The skies, which are blends of two or three colors made on the screen with the squeegee, take even longer, and because the colors never blend evenly each print ends up slightly different.

Although I have tried drypoint, etching, and aquatint—the more traditional printmaking techniques—working with silkscreen has been like a perfect marriage for me. I love the tension that comes from the seemingly contradictory attempt to create a three-dimensional space with a two-dimensional medium that, unlike oil or etching, wants to *stay* flat. Silkscreen does not have the mysterious velvety depths of drypoint, or the liny thickets of etching, but these techniques were invented to realize other approaches to image-making in other eras. Aquatint, for example, was invented to approximate

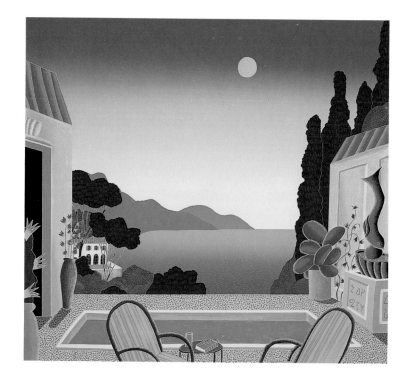

the atmospheric washes of early-nineteenth-century English watercolors, and it seems to me that when a modern artist employs it, his work cannot escape a reminiscent echo of that time.

Silkscreen is unambiguously of our time. It aims toward the emphatic, the iconic, the clear color with a velvety surface, the sharp edge—all qualities I like. It is not a medium for secrets or indecision, and it is merciless with mistakes. Many serigraphers use only part of the available orchestra and produce the garish, half-baked, or bleached-out prints one sees around. The challenge is to use silkscreen for all it's worth, to

Opposite
Riviera Villa. 1982.
Silkscreen, 24 × 25¾"

Tarrytown. 1983.
Silkscreen, 23⅞ × 27¾"

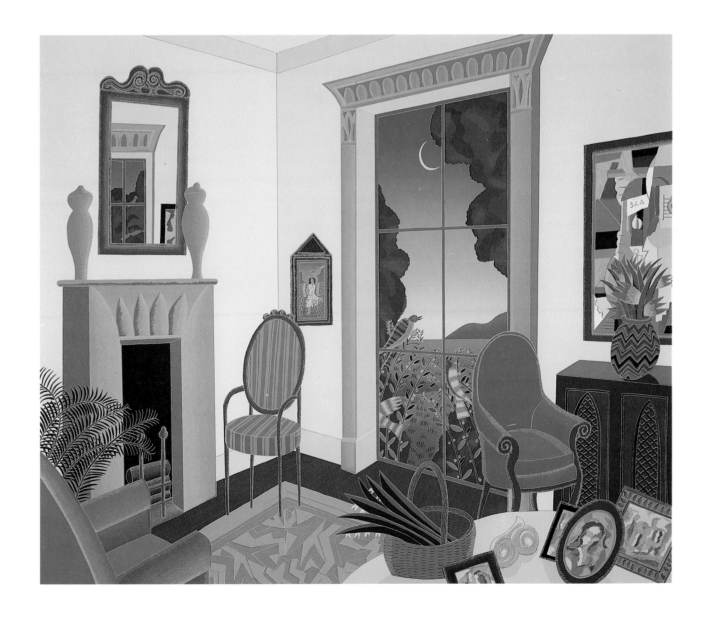

Opposite

French Court. 1981.
Casein on canvas,
38 × 40″. Collection
Mr. Alan R. Gronsbell, New York

North Shore. 1983. Casein
on canvas, 28 × 32″.
Chalk & Vermilion Fine Arts, Ltd.,
New York

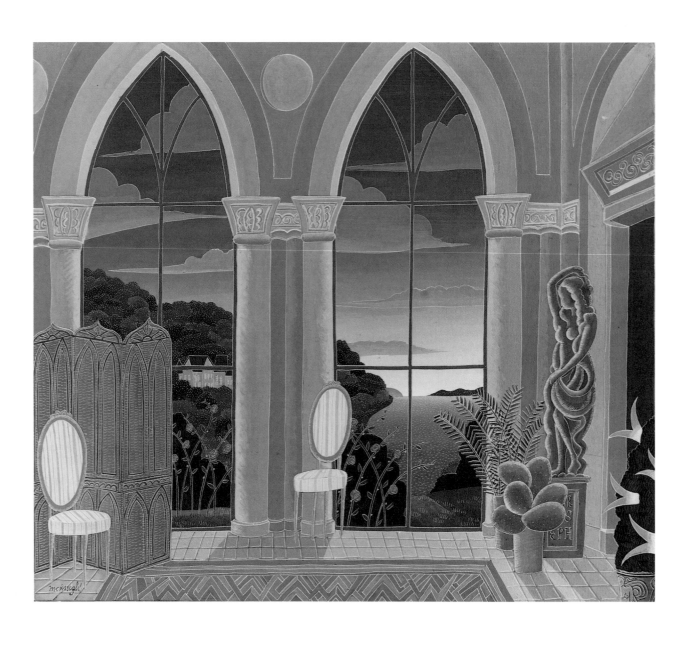

exploit all of its positive elements. Unlike other techniques with long histories, serigraphy is only at its beginnings. Just as much of the best work in woodcutting, engraving, and lithography was done soon after these mediums were developed, the best silkscreens ever made are being created in workshops as you read this.

If I had to put them in order, the images that I make might be placed into three broad categories. First, and closest to my core, perhaps, are the symbolic figures—nymphs and gods, creatures of the vine, monsters and other personages of uncertain provenance. One of them usually dominates a picture, but sometimes they appear in groups as players in dramatic events or allegories. These creatures demand to be brought into the material world. When they have materialized they demand to be looked at. Their presences seem to contain energies that a gaze unlocks.

Second are images of places based on both real and imaginary models. These come from childhood memory (surburban scenes); travel (Venice); reveries of the close (Manhattan), the faraway (Mykonos), and the past (Atlantis). They are built up in a complex interchange between the initial idea (surrounded always with the nimbus of possibility, which is a certain kind of excitement), the known aspects of the scene

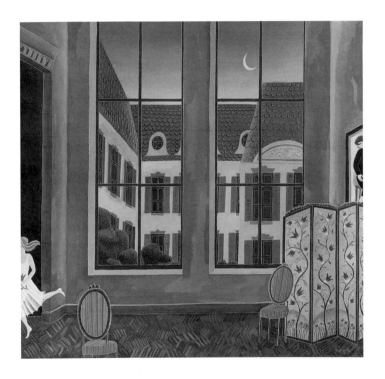

(if known), and the technical problems of the composition itself.

Finally, there are enclosures. What they have in common is an interplay between the geometry of man-made architecture and artifacts and nature. They are interiors, gardens enclosing space, courtyards, or paintings of rooms where other paintings hang. Of all the three categories, these enclosures are the closest thing I do to pure painting for the joy of color, composition, and invention. The initial idea for one of them might be something as slight as an

Opposite
Detail of *Narcissus*

Narcissus. 1982. Casein
on canvas, 24 × 26″.
Collection the artist

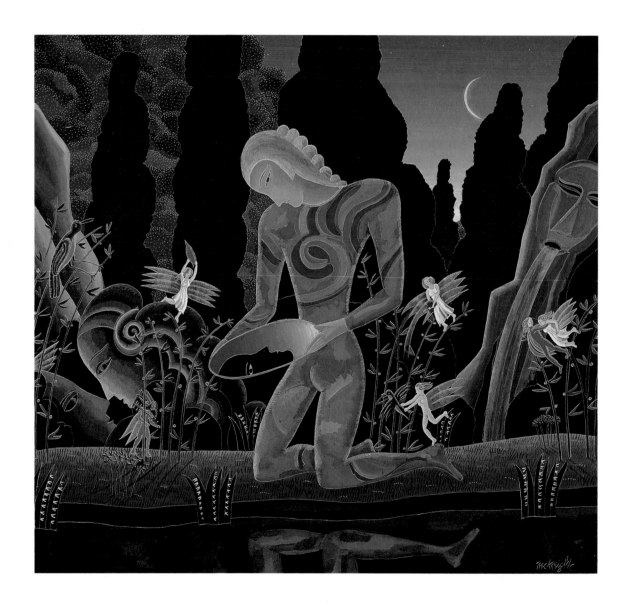

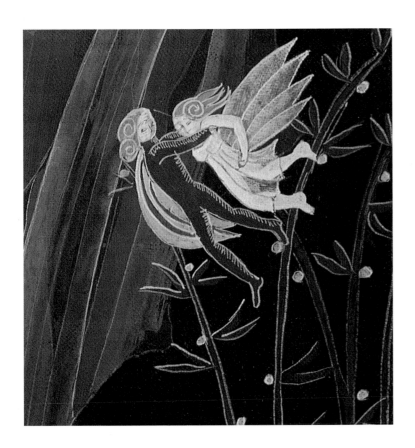

The image of Narcissus came into my head almost in the same pose as the White Rock girl but more yearning, the head more inclined. Narcissus, the youth who was in love with his reflection, has been called the inventor of painting—perhaps because of his preoccupation with image.

Following my conception of him, I wanted to place him exactly halfway between man and woman, so that neither sex could claim him but both could identify with him. The background elements took shape after numerous drawings and erasures on the canvas. The elements that finally seemed right remained. Why they seemed more right than what was erased is the greatest mystery to me, but one argues with what the gods want at one's peril!

The nymphs, gnomes, birds, and flowering bushes were added afterward—technically to enliven the dark areas, otherwise to bring into vision the spirits of the flowers, bushes, earth, and water that surround Narcissus and us.

When I finished the painting I felt I could give it this interpretation: between the primitive life of love (on the right), and the balanced expression of love (on the left), Narcissus is the transforming and transitional stage. Here the other at which he stares (as if in a mirror) is his shadow.

open window on a sunny day, but from that a whole structure can be built up. Like a *capriccio* of Canaletto or Piranesi, they combine known elements in new and striking ways.

In the following commentaries, I sought to explain the origin and some of the thought processes that go into one work in each of these three categories.

Here is a room with a view that attempts to embody the soul of the Mediterranean, which for me is the magnetic center of all of civilization. The inspiration was to create a space that Bernard Berenson might have liked, perhaps even lived in if he were alive today.

Each part engendered another. The yellow chair called forth a blue couch. They both demanded an orangy terra-cotta wall. The landscape outside suggested the cactus, palm, and painting of classical ruins inside. The ruins suggested the statuary group, the broken column, and the door pediment. The picture frame evoked the *cassone* underneath. The Gothic window frames give the impression that the villa is owned by a neo-Ruskinian, if there are any left—or at least by someone from north of the Alps.

The title *Antibes* came last, because when the painting was finished it looked as if it could be located in that Côte d'Azur resort. However, it could have been called Cap Ferrat or Rapallo with equal validity. I knew I had finished the painting when nothing in it jarred me, and when I felt that I too could be happy living in its space.

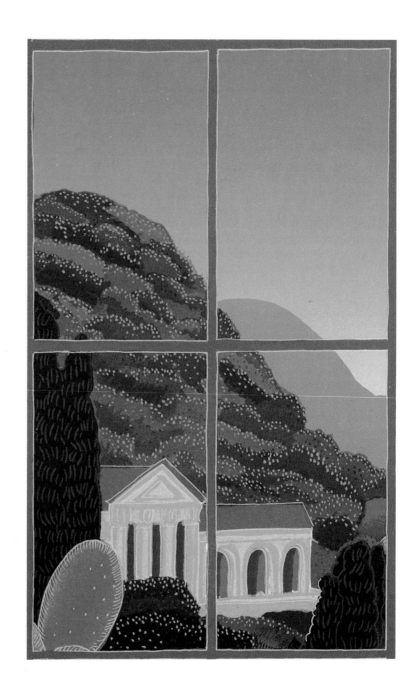

Opposite
Detail of *Antibes*
Antibes. 1984.
Silkscreen, 25⅞ × 29⅞″

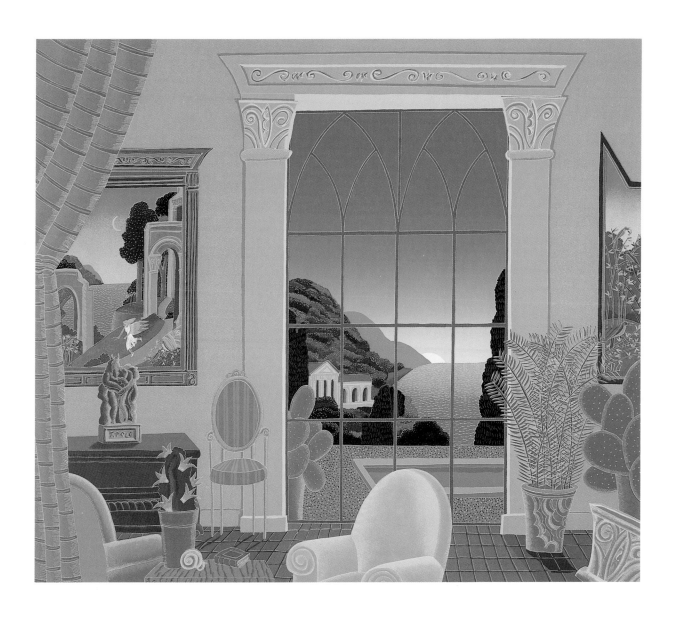

The foreground here is based loosely on the Gritti Hotel's dining terrace in Venice. The picture was inspired by a memorable meal there on my wife's birthday. The background is a somewhat impressionistic view across the Grand Canal. On the Canal was a flotilla of gondolas serenaded by a mandolin-playing gondolier, who sat in the boat strung with lights. As it passed by (during dessert), his song echoed back and forth from the illuminated church of the Salute and the palaces opposite.

That evening a waiter with white gloves misdirected a bottle of rare red wine intended for a nearby oenophile to us. We had polished off half of it before the mistake was discovered. It tasted velvety and smooth, redolent of old violins and flowers.

The challenge was to convert this scene, which Jean Cocteau once called one of the most beautiful spots in the world, into a work of art that was not hackneyed. I executed the painting from memory, although I used photographs to get the architectural details of the buildings opposite approximately right. I left out the people so that anyone could imagine himself there.

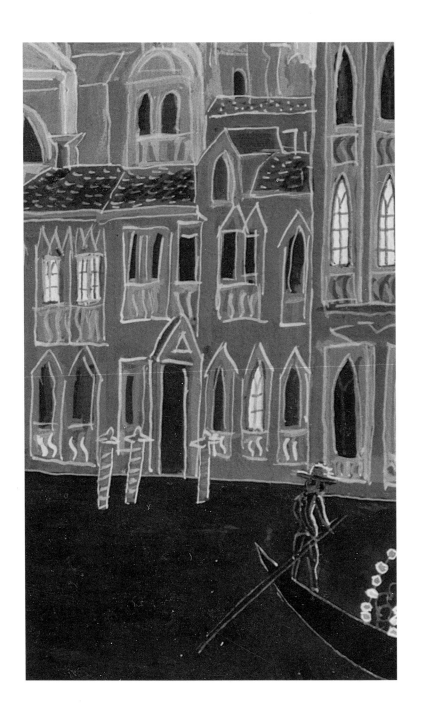

Opposite
Detail of *Evening on
the Grand Canal*

Evening on the Grand Canal. 1983.
Casein on paper, 14 × 16".
Collection the artist

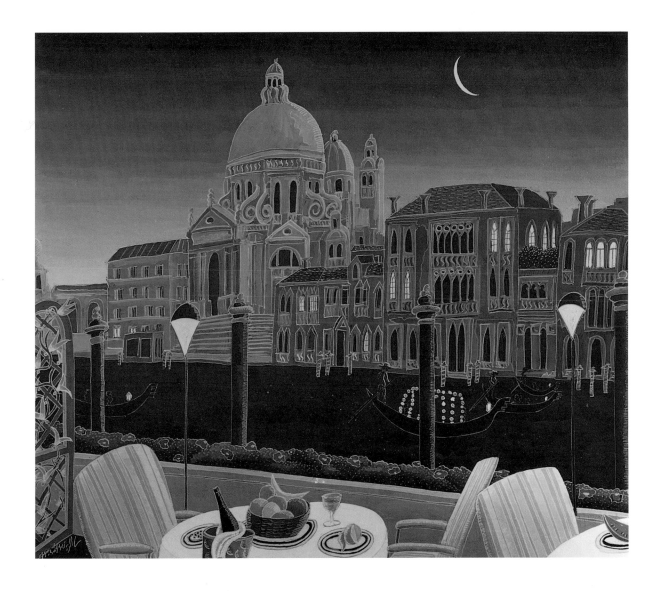

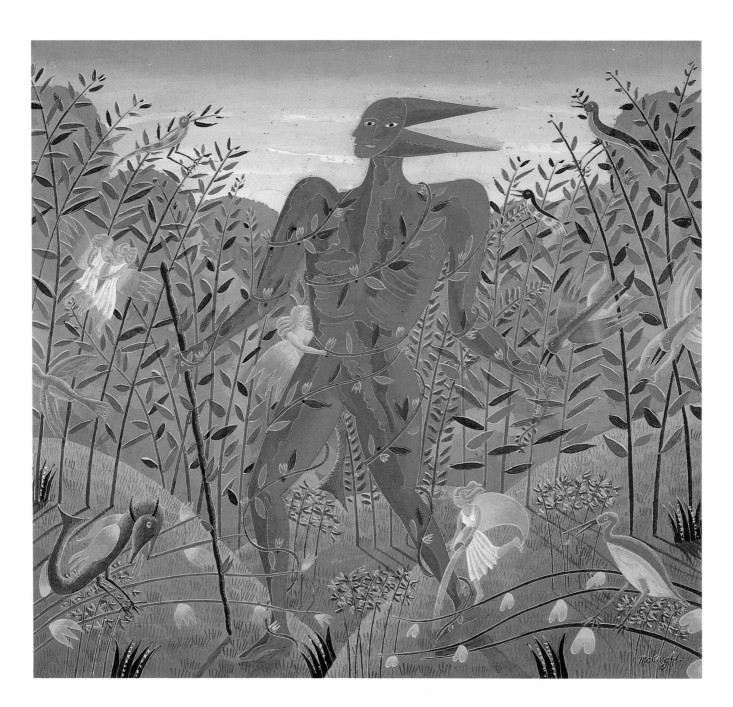

Blue God. 1982.
Casein on canvas, 24 × 26″.
Private collection

IMAGES

On the following pages is a brief excursion to those places and things, both real and imagined, that serve as subjects for my work.

Rather arbitrarily, they have been divided into broad categories that, like the waters of the Nile delta, sometimes wander into other channels.

GARDENS

Gardens have a universal human fascination because
they reconcile man with nature, and tame the excesses
of both. I like two kinds of gardens: secret enclosed
spaces, almost natural rooms, with sometimes the hint
of the presence of a pagan *genius loci*; and flowery, bird-
filled groves through which one observes far, transcen-
dental vistas.

Preceding page
Detail of *Conservatory*.
1981. Silkscreen, 25¾ × 24″

Opposite
Moor's Gardens. 1981.
Casein on canvas,
28 × 26″. Private collection

Gazebo. 1980. Casein
on canvas, 26 × 28″.
Private collection

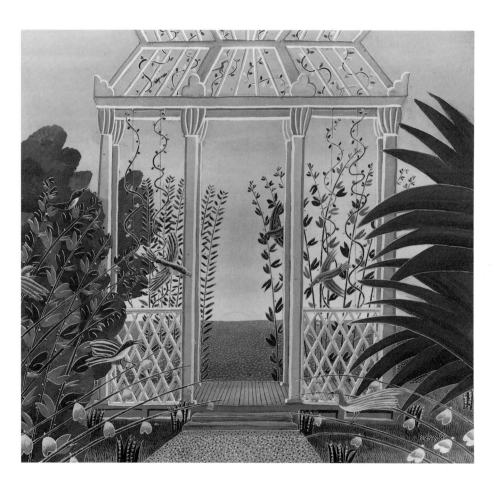

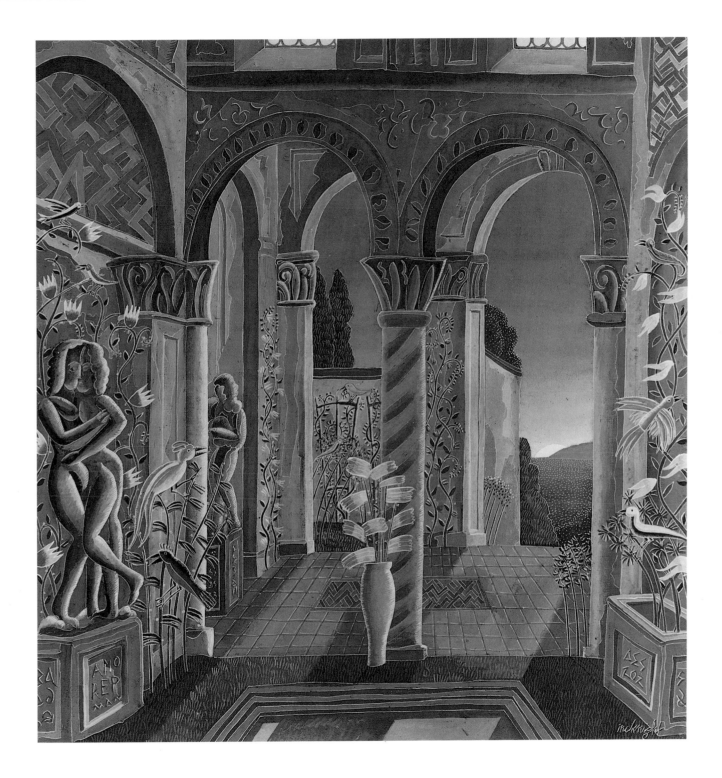

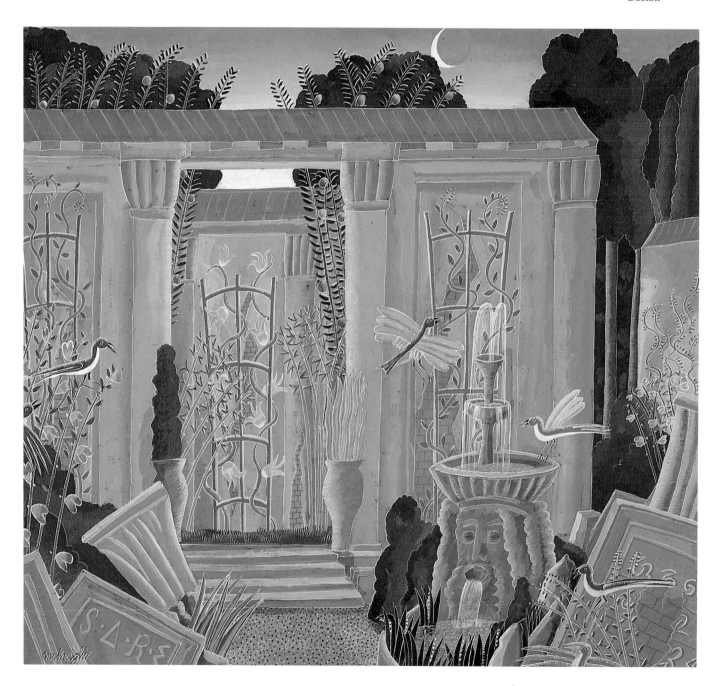

Austrian Garden. 1983. Casein
on canvas, 28 × 30″.
Private collection, Vienna

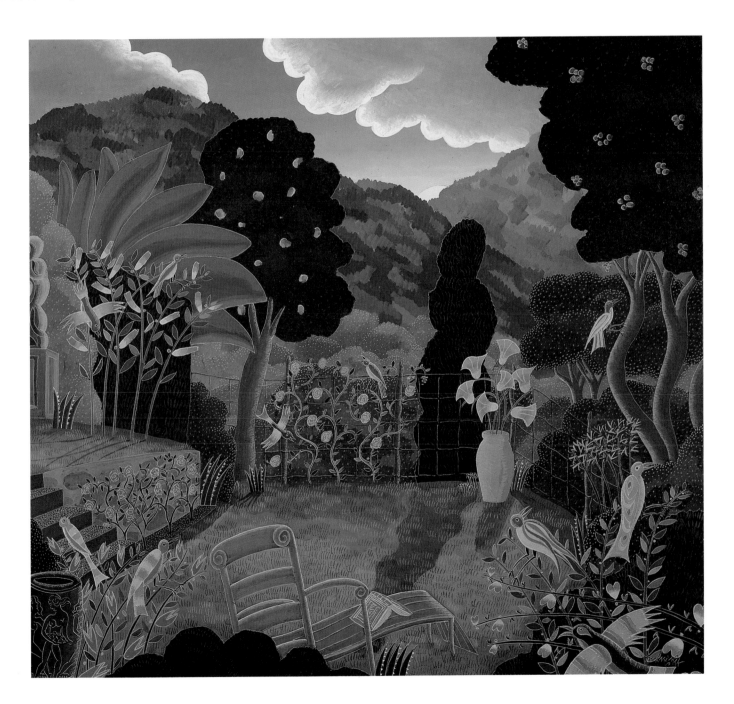

PICTURES IN PICTURES

Matisse, Picasso, and Léger seem to best counterpoint the interiors in which I place them, and not simply because they are the easiest to copy. As Marshall McLuhan used to say, new art encapsulates what came before — but I don't know if he meant it so literally!

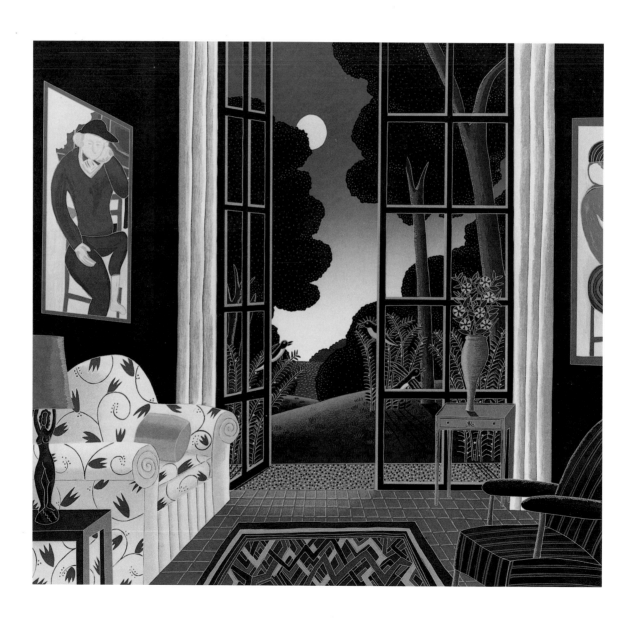

Opposite
Princeton. 1982.
Silkscreen, 24 × 25⅞″

Les Demoiselles d'Avignon. 1981.
Casein on canvas,
24 × 26″. Private collection,
Scarsdale, New York

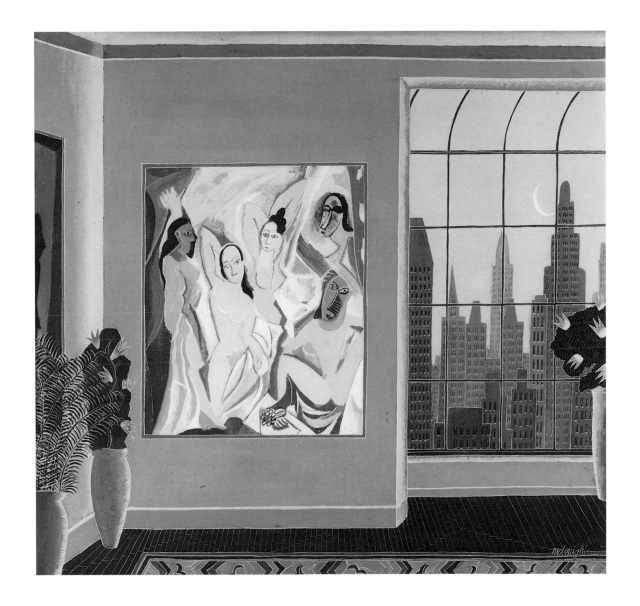

Opposite
Harlequin. 1982.
Silkscreen, 24 × 27″

Loft with Cubist Picasso. 1981.
Casein on canvas, 26 × 30″.
Private collection

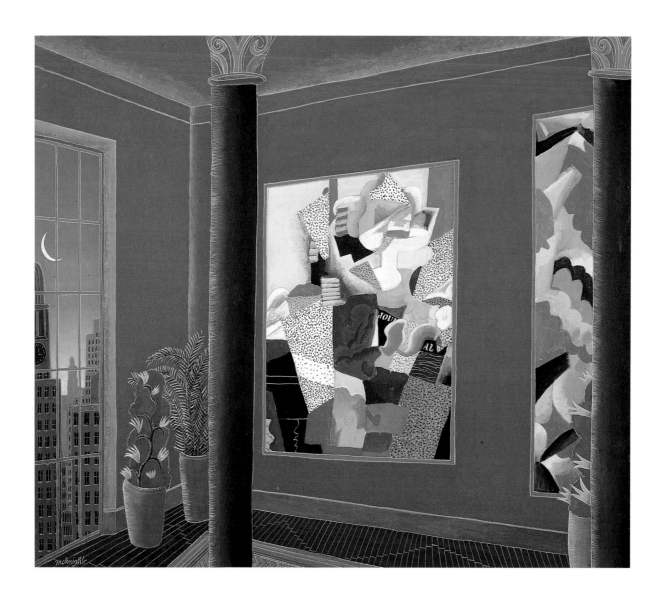

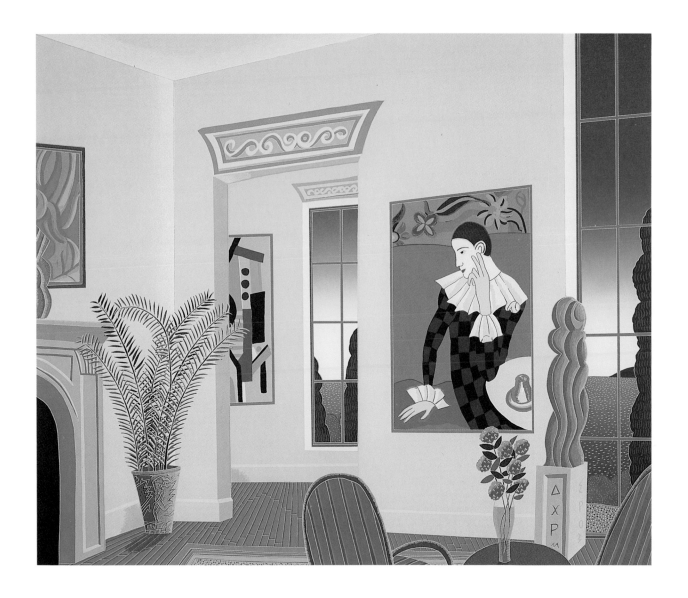

NYMPHS

Teeming nature is tamed by wild nymphs who act as
focal points for man's imaginings. Life is like a labyrinth
in which the nymphs entice, guide, and lead astray. The
myth of Apollo and Daphne is a symbol to me of the
metamorphosis of art, turning emotions into dead mat-
ter (paper, canvas, and pigment), which has the miracu-
lous power of generating emotion again.

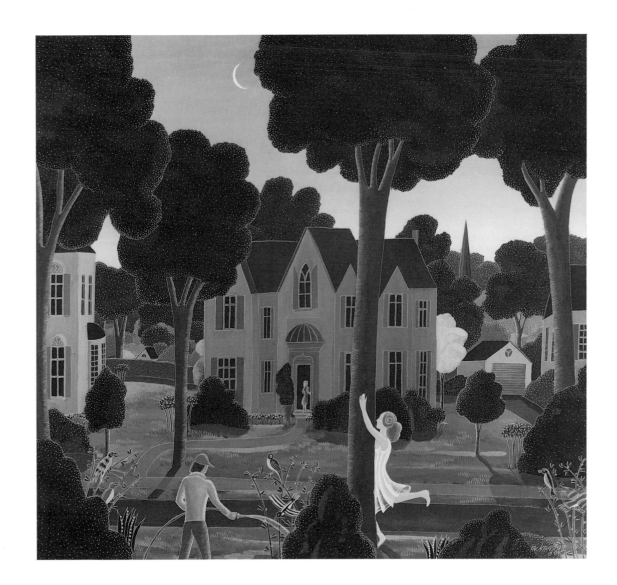

Opposite
Daphne in Westchester. 1983.
Casein on canvas, 28 × 30".
Private collection

Left
Mars and Venus. 1979.
Casein on canvas, 24 × 26".
Private collection

Right
Nymph and Satyr. 1982.
Casein on paper, 14 × 16".
Private collection

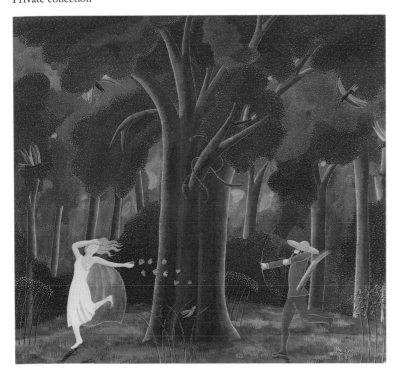

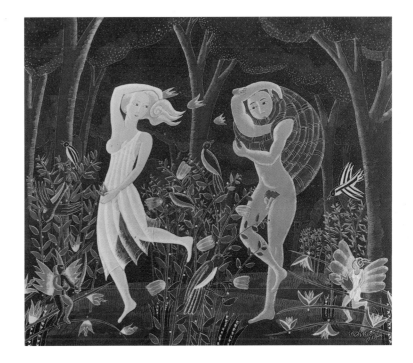

Opposite
Mezzetino. 1983. Casein
on canvas, 30 × 28″.
Private collection

The Green Maze. 1981. Casein
on canvas, 24 × 26″.
Collection Renate McKnight,
New York

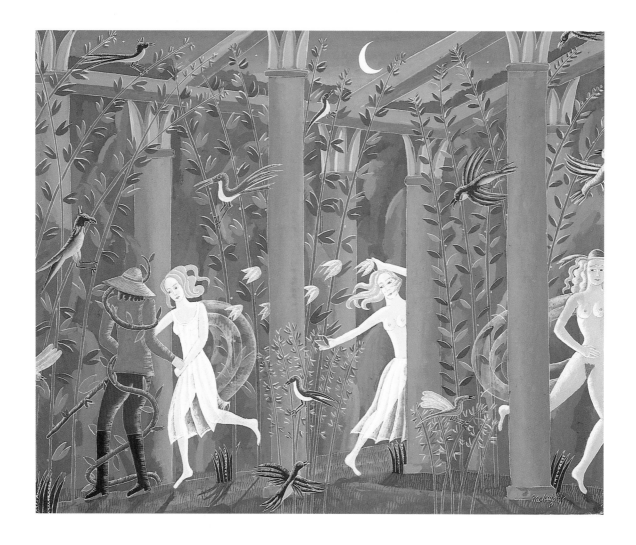

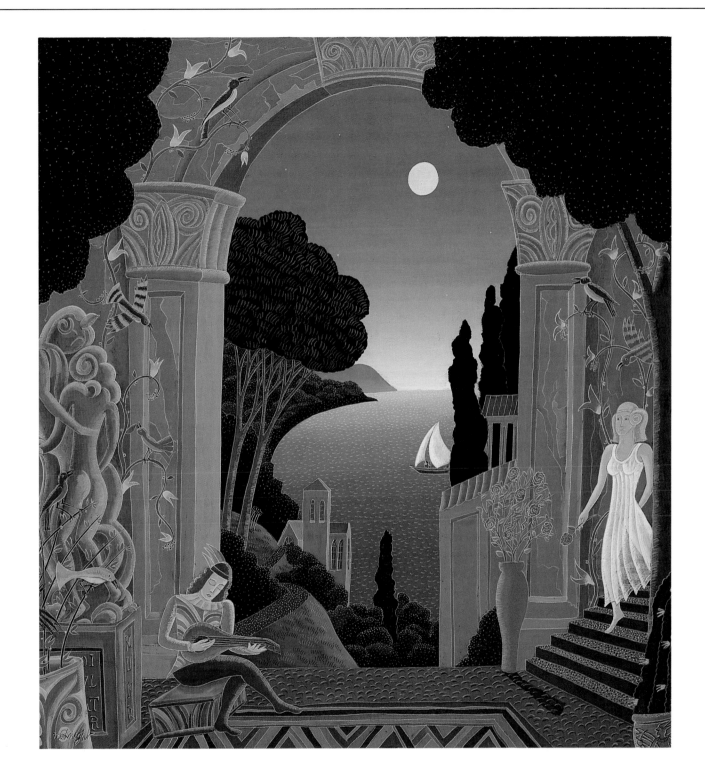

VENICE

Painting Venice is almost always doing a variation on a theme. Most of the views here have been going strong for at least several hundred years. I try to flirt with the cliché and combine the Venice of history with that of food, flowers, and gondola rides.

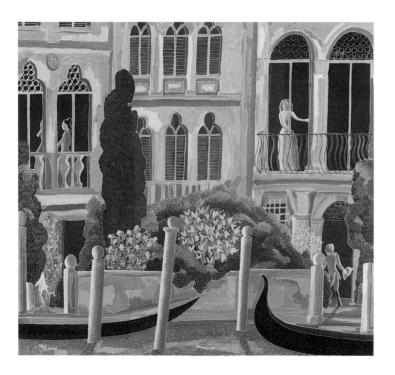

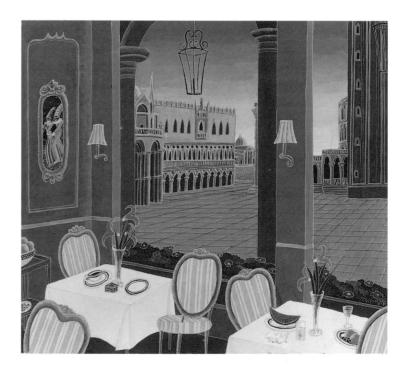

Rialto. 1982. Casein on
canvas, 28 × 30″. Collection
Mr. and Mrs. Ernst Hödl,
Scheibbs, Austria

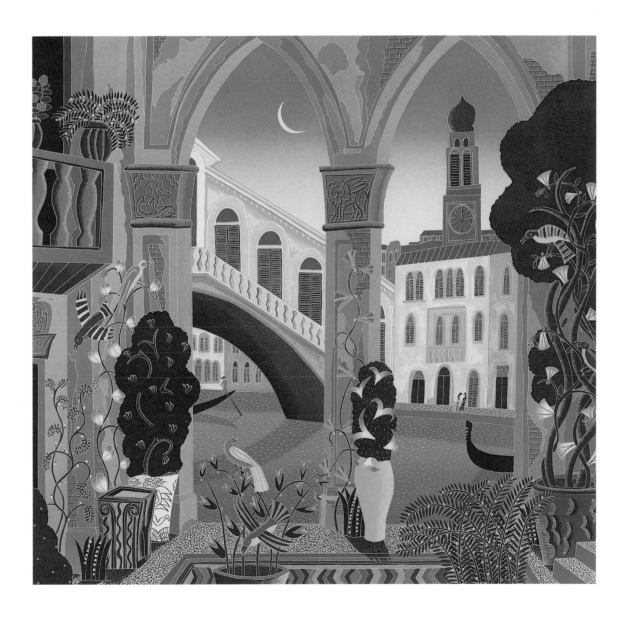

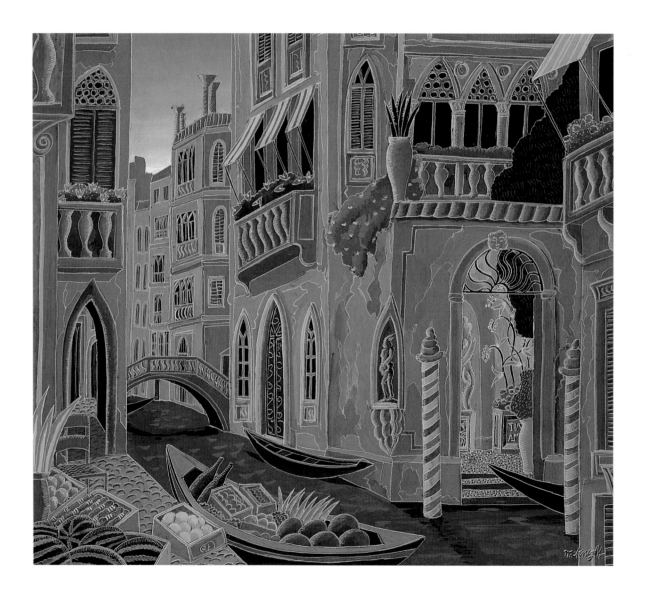

Opposite
Palazzo with Garden. 1983.
Casein on paper, 14 × 16".
Collection the artist

Casanova in Venice. 1981.
Casein on canvas, 26 × 28".
Collection the artist

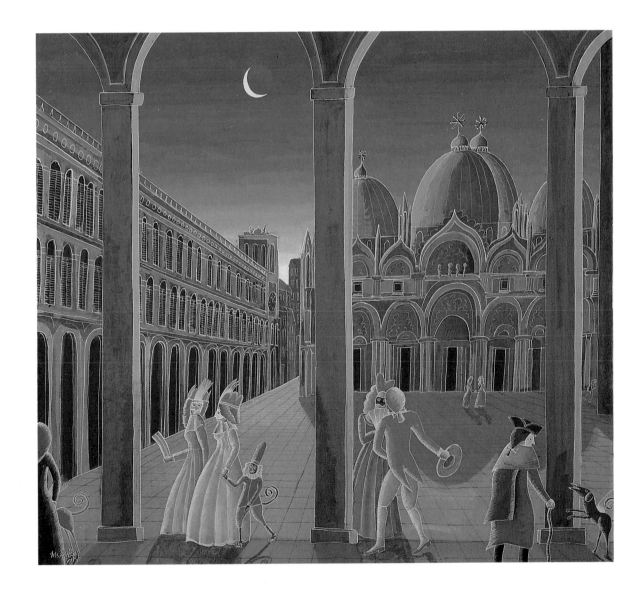

CLASSICAL FABLES

To paraphrase James Hillman, the noted neo-Jungian author of *Re-Visioning Psychology*, a "return to Greece" is periodically necessary in our civilization to rediscover the archetypes of our minds and culture. This return took place in the Renaissance, and, more recently, in some of the work of Stravinsky, Picasso, and Joyce. It is a return to "*where* the Gods *are* and not *when* they were or will be." It is a psychological response to the challenge of breakdown and "offers us a chance to revision our souls and psychology by means of imaginal places and persons rather than historical dates and people."

Opposite
Eros and Saturn. 1982. Casein on paper, 16 × 18″.
Collection the artist

Sleepers. 1982.
Casein on paper, 16 × 18″.
Private collection

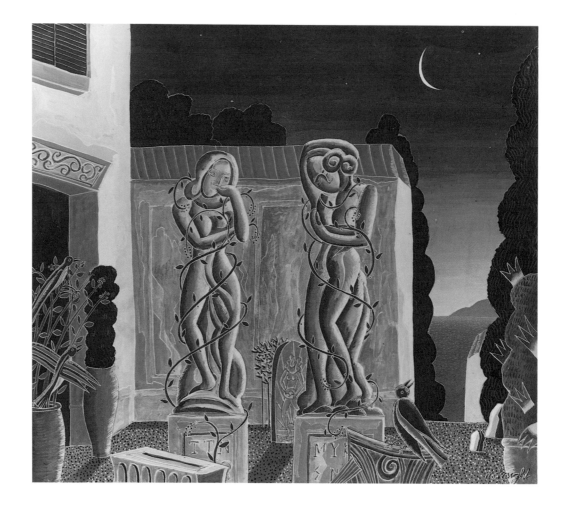

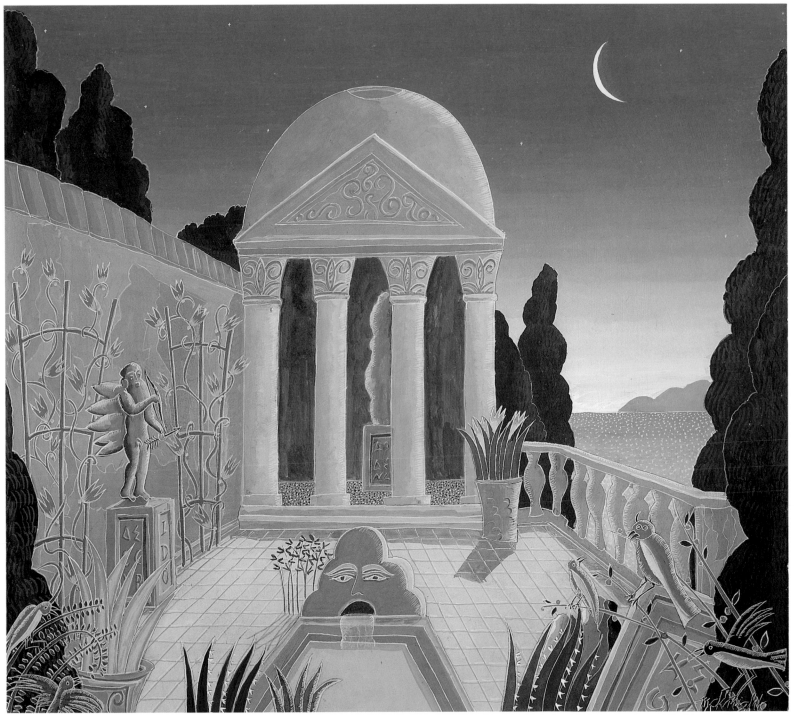

LAOCOÖN

That most famous and beloved rediscovery of the Renaissance, the Laocoön is a statuary group of which I have painted many variations. Laocoön was a priest of Troy who had the temerity to guess the truth about the Trojan horse, only to be howled down by the populace. He was subsequently killed with his sons by two giant pythons which suddenly came out of the sea. For me, the Laocoön represents the struggle to create and tell the truth. Laocoön in the middle finds his energy by struggling against the serpent with his two sons—symbol of his two sides, light and dark. The sacred python, the kundalini, is the chord that unites them all.

Opposite
Laocoön. 1983. Casein on canvas, 28 × 30″. Collection the artist

Left
Egyptian Garden. 1981. Casein on canvas, 26 × 24″. Private collection

Right
Eros and Psyche. 1982. Casein on canvas, 26 × 28″. Chalk & Vermilion Fine Arts, Ltd., New York

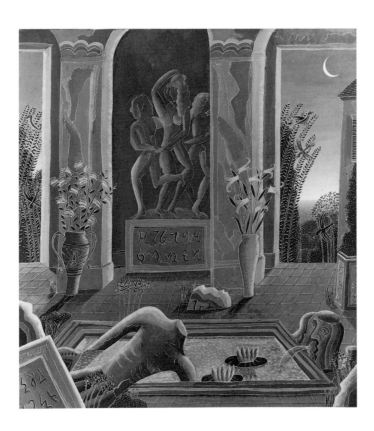

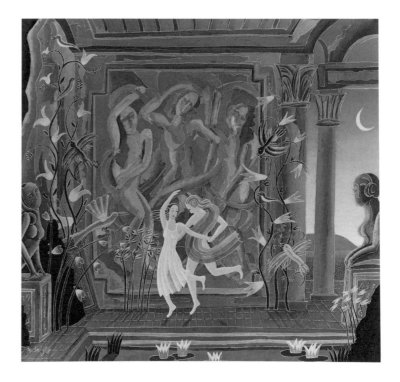

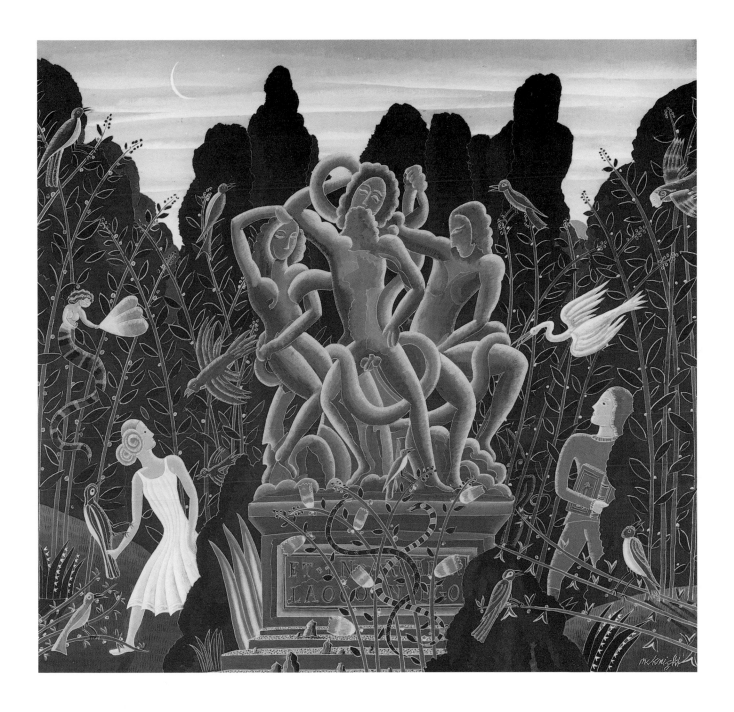

IDEAL SPACES

Interiors can represent a perfect order as they tame nature and man-made things by squaring them off, framing them, and putting them in their place. Perhaps it is in paintings and prints like these that my work comes closest to music, weaving melodies from shapes and colors as they interact with each other.

Opposite
Conservatory Facade. 1982.
Casein on canvas,
30 × 28″. Private
collection, New York

Conservatory. 1981.
Silkscreen, 25¾ × 24″

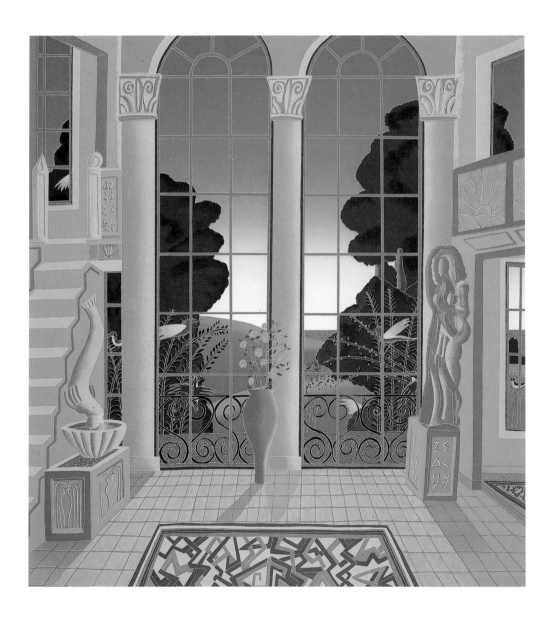

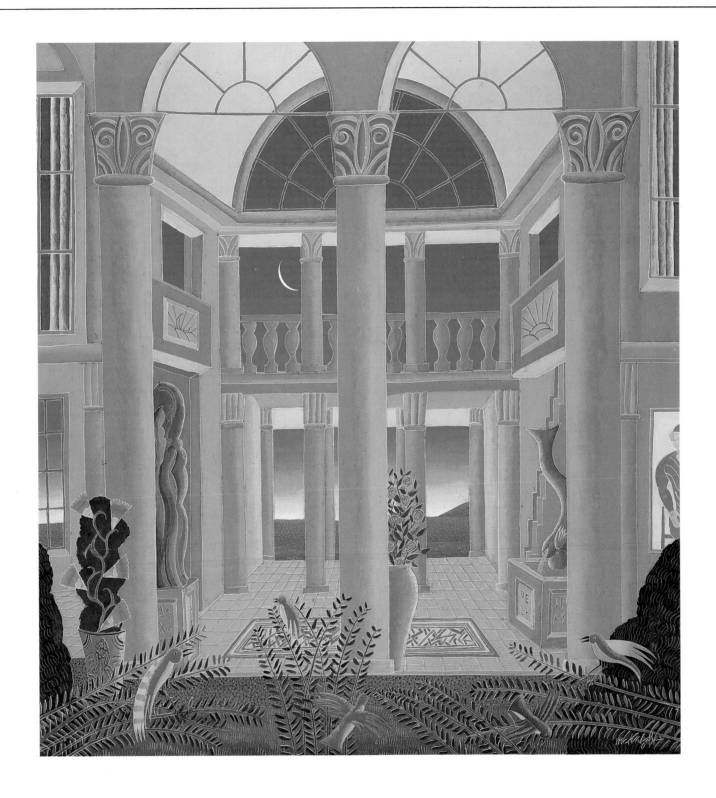

Opposite
Stair Runner. 1981. Casein
on canvas, 26 × 28″. Private
collection, New York

Lake George. 1983. Casein on
canvas, 26 × 28″. Collection
Mr. and Mrs. Jack L. Baylin,
Baltimore

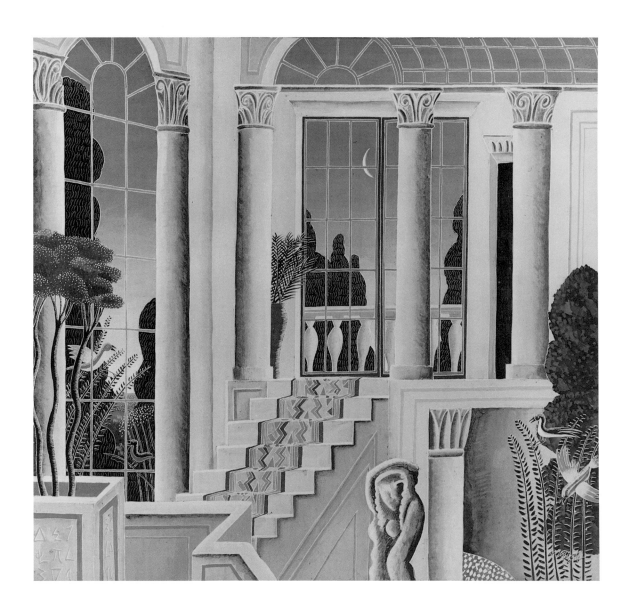

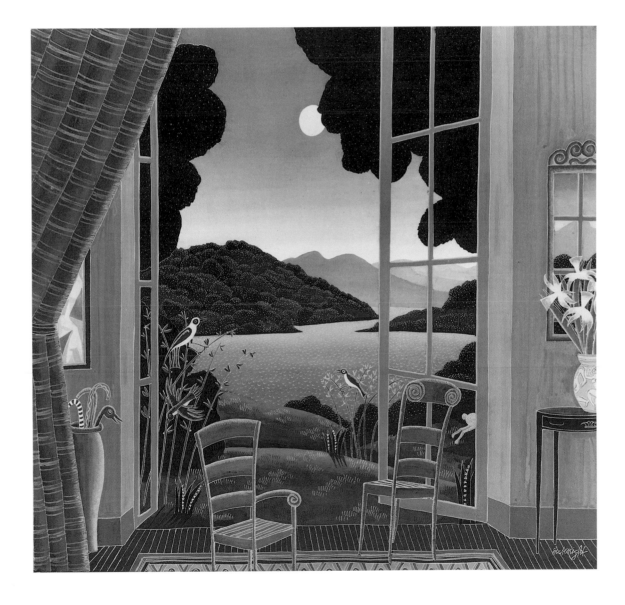

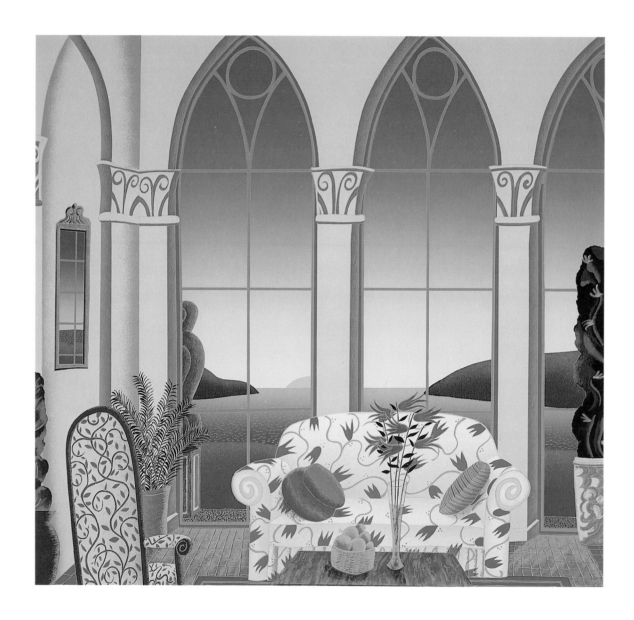

Opposite
Flowered Couch. 1982.
Silkscreen, 24 × 25¾″

Red Room with Guitar. 1983.
Casein on canvas, 26 × 30″.
Private collection, Charleston,
South Carolina

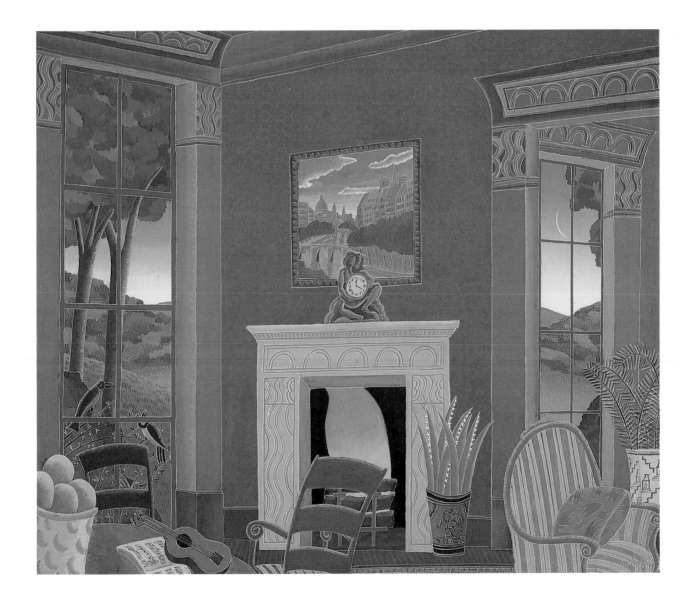

ALLEGORIES

Strictly speaking, these are not allegories since the figures and settings do not stand for a readily identifiable something else. But, in another sense they are allegories in that around their elements stories or metamorphoses might be woven. As patterns for allegories to be invented, they aspire to the state of music.

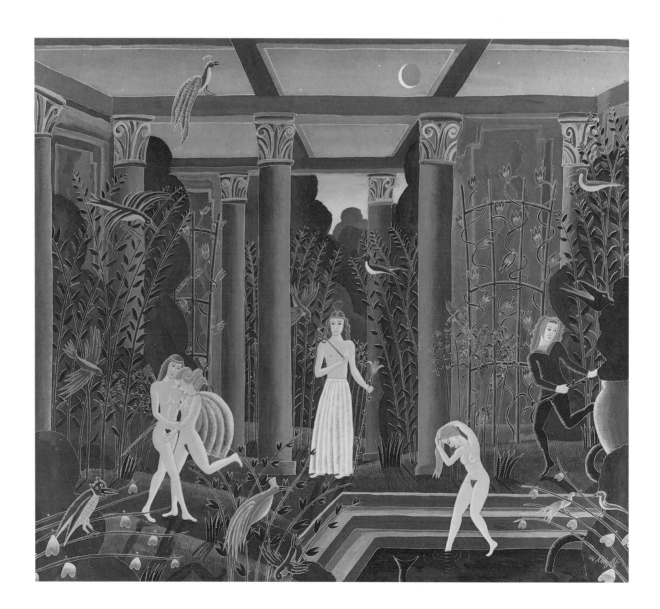

Opposite
Garden of Isis. 1981.
Casein on canvas, 36 × 40″.
Private collection

Allegory of Life. 1983.
Casein on paper,
overall center panel 26½ × 18½″;
side panels 18½ × 8½″

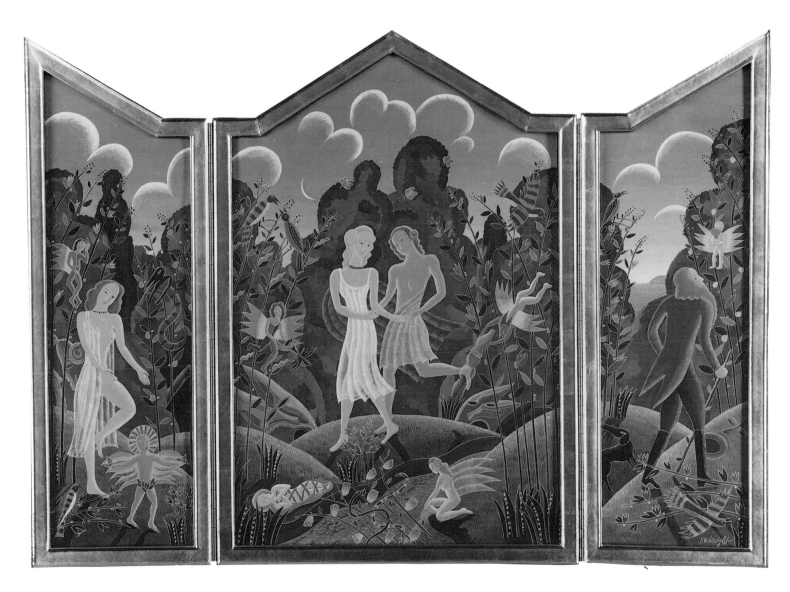

Left
Black Knight. 1981.
Casein on canvas,
14 × 16″. Collection
Mr. Fernando Bartolomé,
Cambridge, Massachusetts

Pan. 1982. Casein on
canvas, 24 × 26″.
Private collection,
Southampton, New York

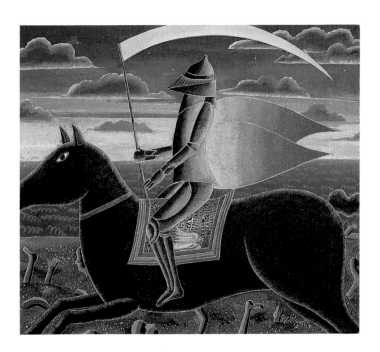

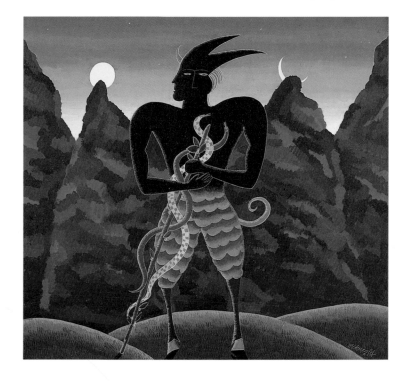

Janus. 1982. Casein on
canvas, 24 × 26″.
Private collection,
Pocantico Hills, New York

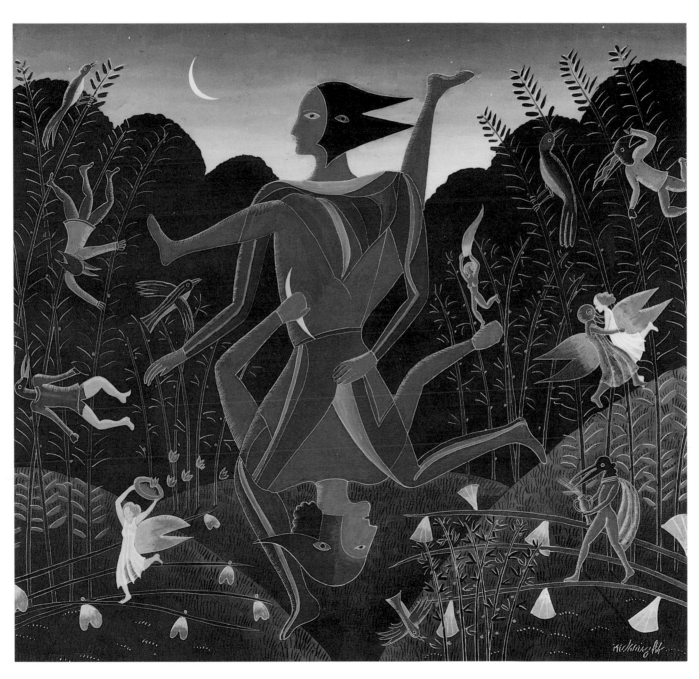

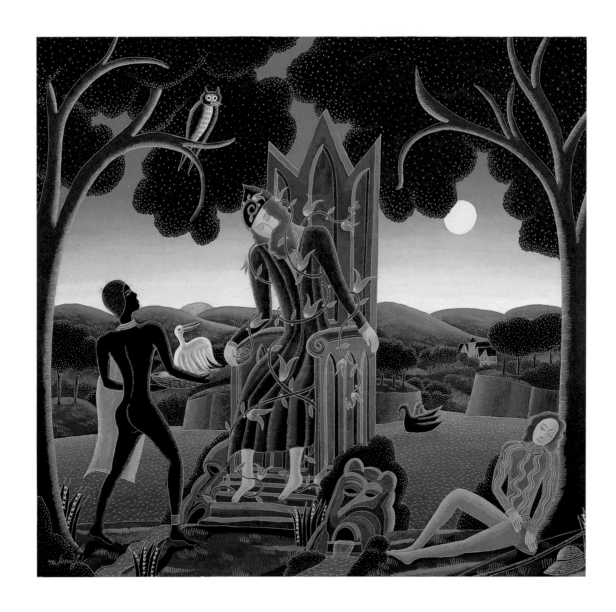

Opposite
The Sleeping King. 1983. Casein
on canvas, 26 × 28″. Collection
Mr. and Mrs. Alan Paller,
Washington, D.C.

Romance of the Rose. 1980.
Casein on canvas,
30 × 36″. Collection
Renate McKnight, New York

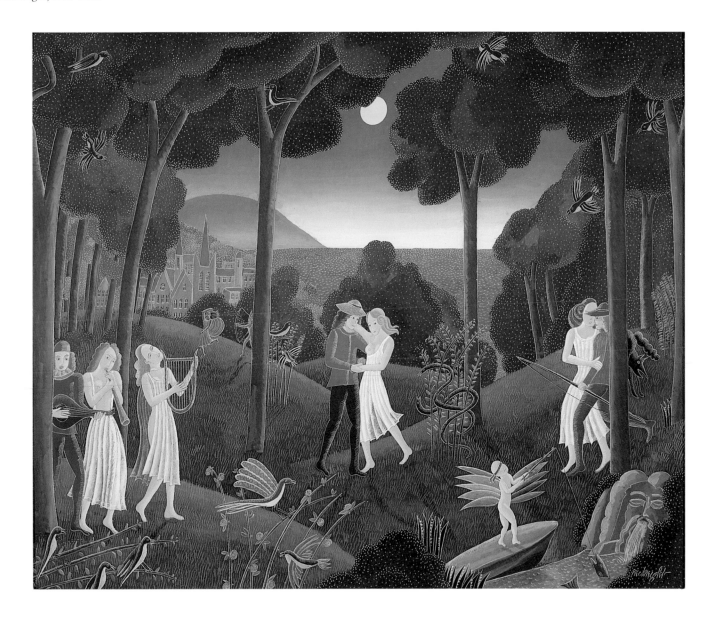

LEGENDARY PLACES

These locations are from a geography of the spirit whose visualization is aided only circumstantially by real architecture and geology. Sometimes they are speculations of what Atlantis might have looked like as filtered through eyes raised on images of Mont Saint-Michel and Druid woods. Sometimes they are inspired by old tales such as that of Tristan and Isolde and the Legend of the Grail.

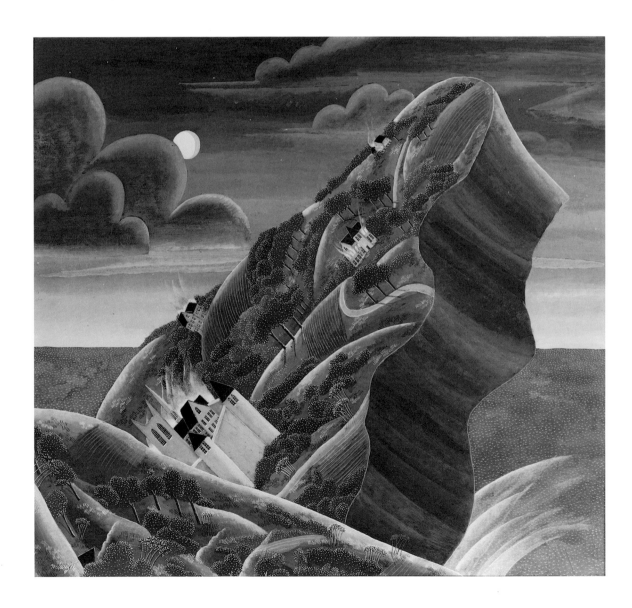

Opposite
Sinking Atlantis. 1978.
Casein on canvas,
36 × 40″. Collection
Mr. Steven E. Garshell,
Highlands, New Jersey

The Wave. 1981. Casein on
canvas, 24 × 26″.
Collection Mr. Fernando Bartolomé,
Cambridge, Massachusetts

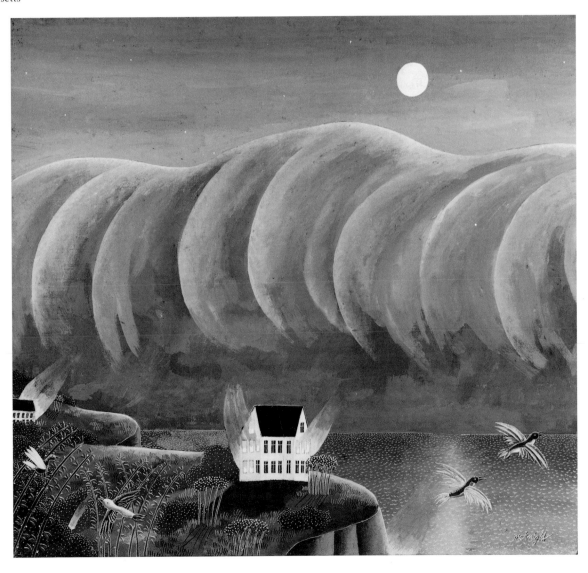

Opposite
The Lighthouse. 1983. Casein
on canvas, 30 × 26″. Private
collection, Montauk, New York

Enchanted Wood. 1983. Casein
on canvas, 32 × 28″. Collection
Mr. and Mrs. Morton J. Stark, Baltimore

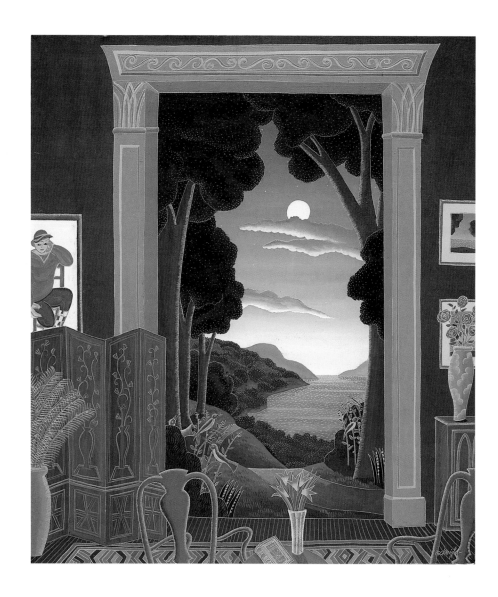

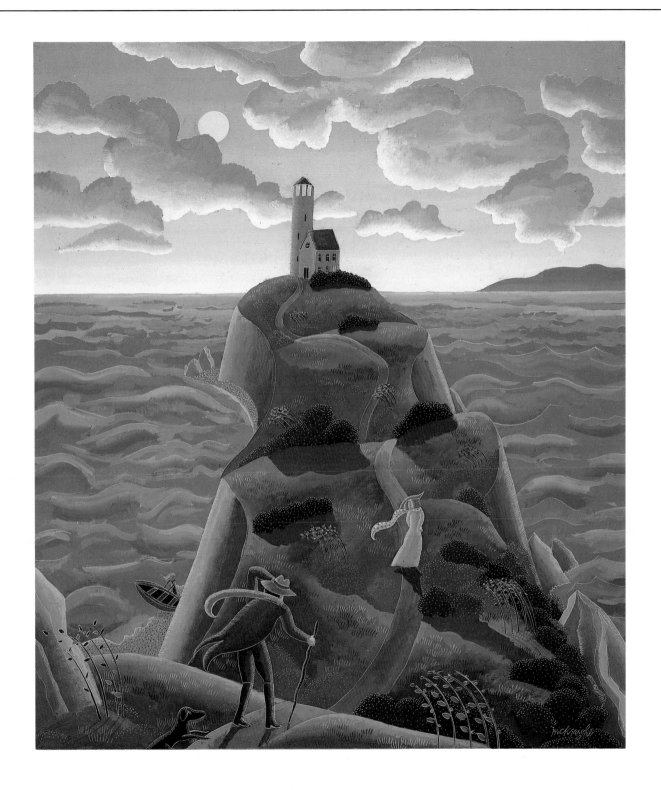

Left
Swan Castle. 1981.
Casein on canvas, 24 × 26".
Private collection

*Caspar Friedrich at
the Beach*. 1980.
Casein on canvas,
22 × 24".
Private collection

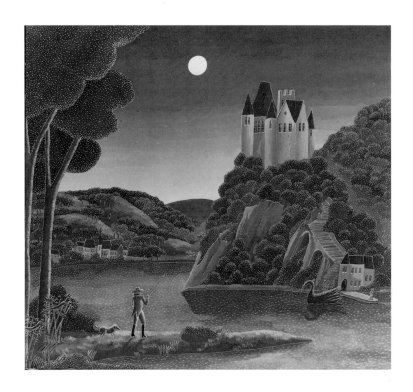

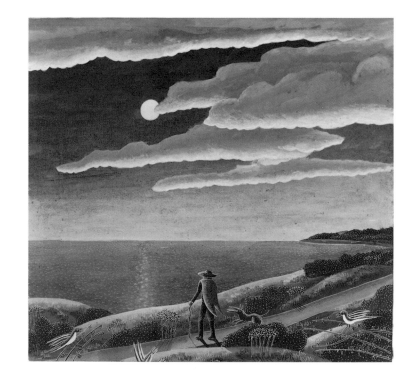

Babylon. 1981. Casein
on canvas, 26 × 28″.
Private collection

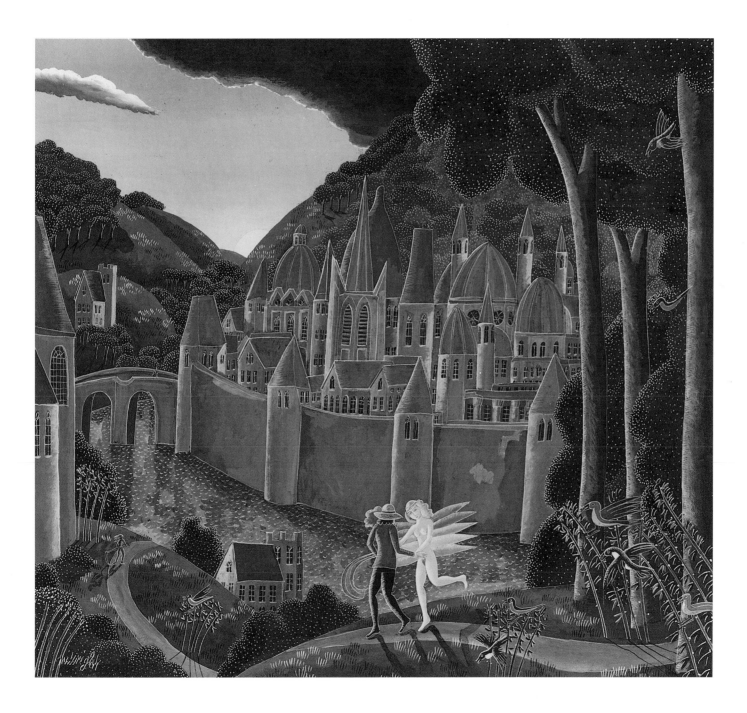

MANHATTAN

New York becomes exotic to me when I have left it—its myth begins as I take one last look back from a taxi speeding to the airport. Painting it at a distance keeps the essential outlines but strains out unimportant, obscuring detail. Reconstructed in memory it becomes more real.

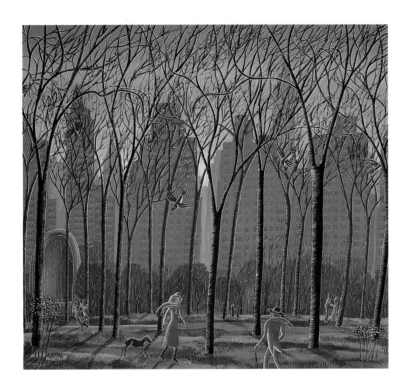

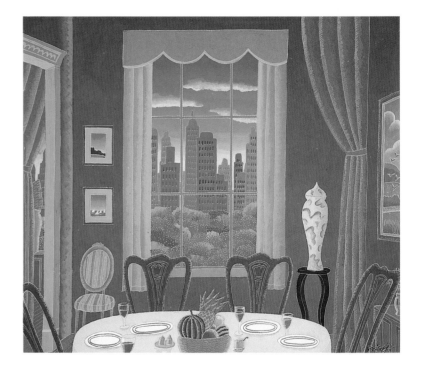

Right
Brooklyn Bridge II. 1981.
Silkscreen, 23⅞ × 27⅞″

*Queensboro Bridge with
Léger*. 1981. Casein on
canvas, 36 × 40″. Collection
the artist

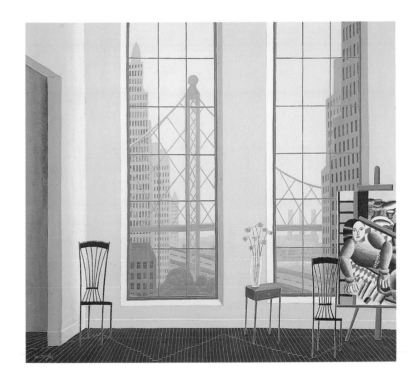

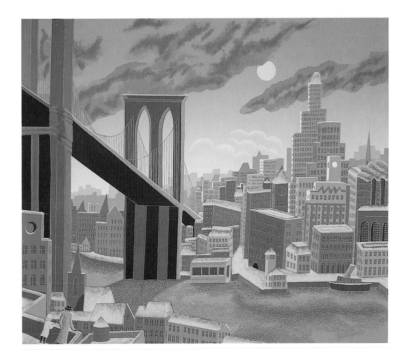

NEW ENGLAND

Although I have only lived in New England during my college years, it is home. It contains the most familiar trees and steeples. Its houses, apples, caned chairs, quilts, and village greens are not exotic to me as is almost everything else in the world—even New York. Yet underneath the whitewashed geometry and the rolling wooded hills, there is an unknown past of Indians, and races even more obscure, that gives the land a resonance as strong as that felt in other ancient places.

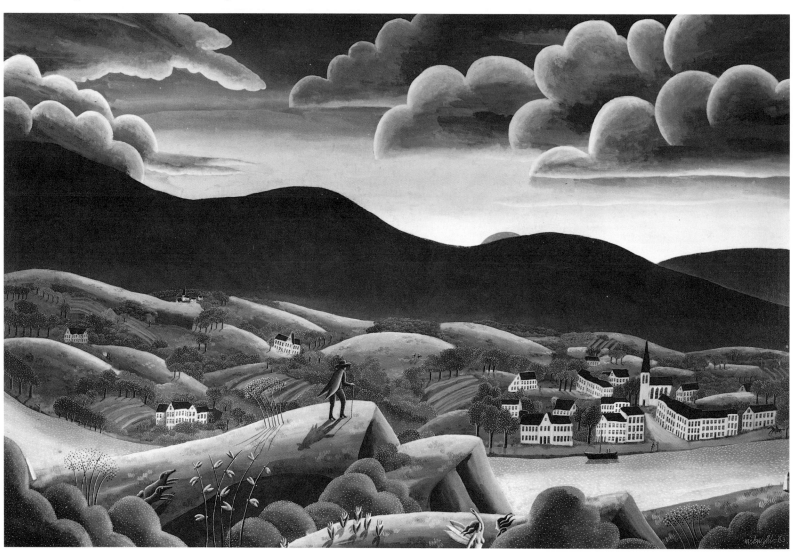

Opposite
New England Valley. 1976.
Acrylic on canvas,
48 × 72″.
Private collection,
Washington, D.C.

Connecticut Valley. 1982.
Casein on canvas,
26 × 28″. Private collection,
Litchfield, Connecticut

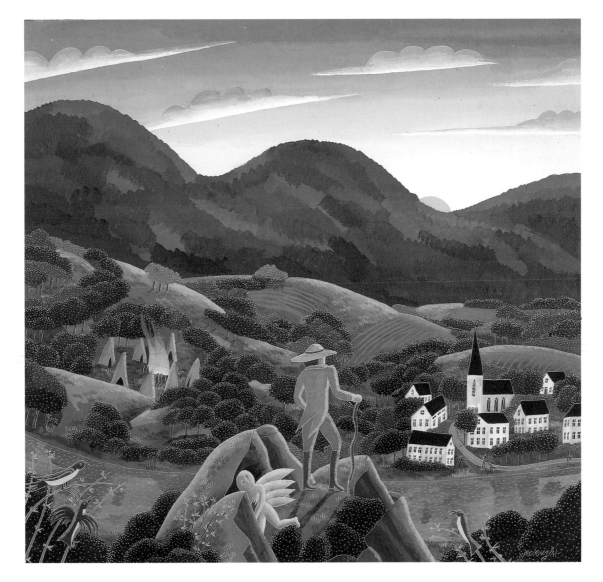

Left

Winter Breakfast Room. 1983.
Silkscreen, 24 × 26¾"

Skating Pond. 1981.
Casein on canvas, 24 × 26".
Private collection

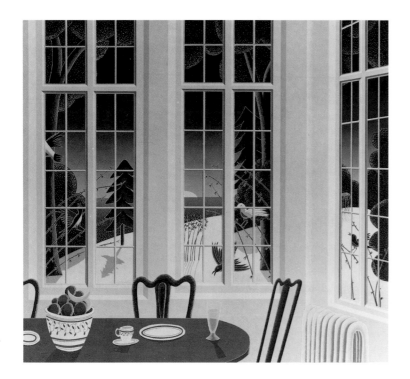

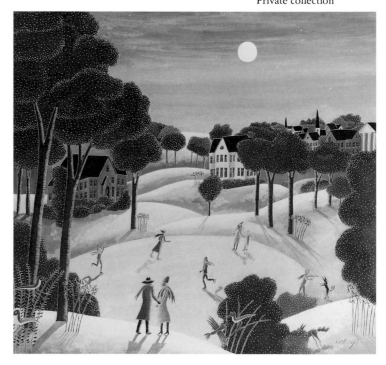

Newport Sailing. 1983.
Silkscreen, 23⅞ × 26⅛″

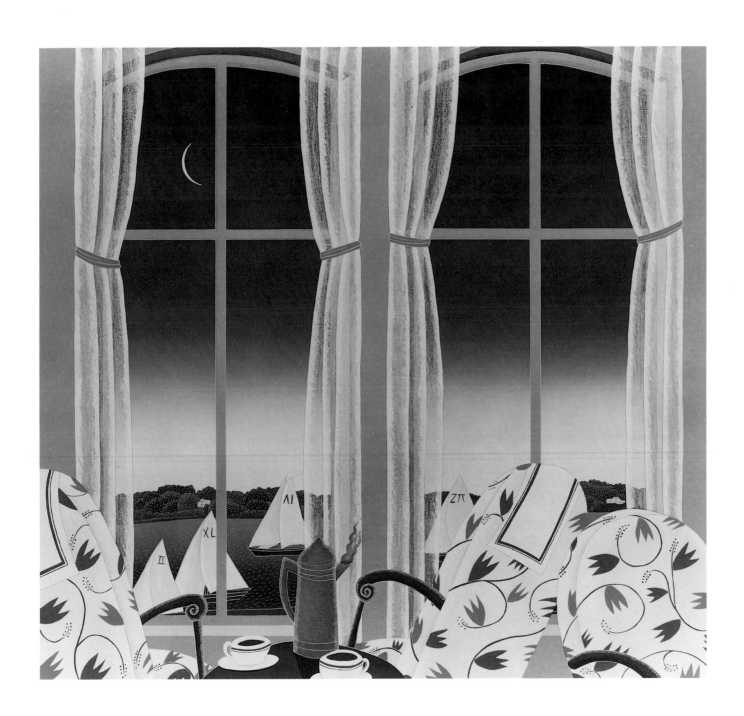

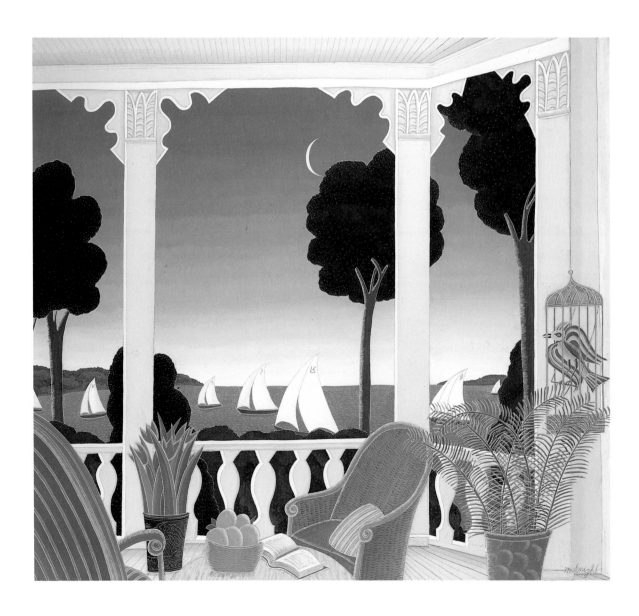

Opposite
Marblehead. 1983. Casein on
canvas, 36 × 40″. Collection
Mr. Alan R. Gronsbell,
New York

Litchfield. 1984. Casein
on canvas, 38 × 42″.
Collection the artist

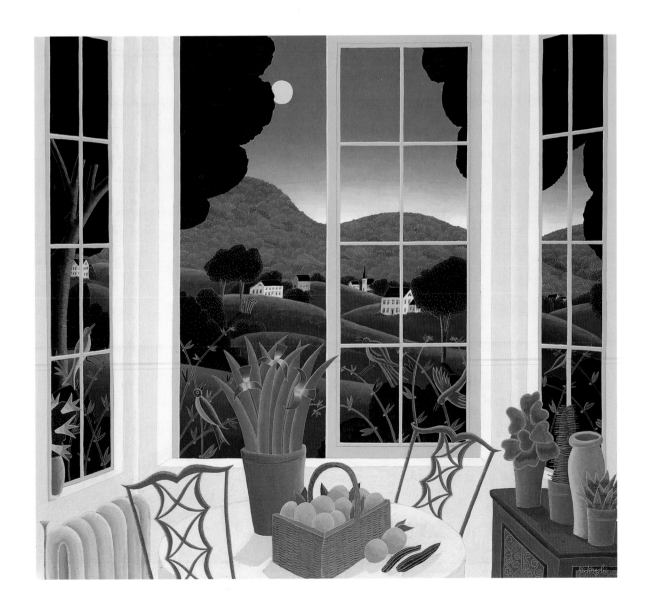

MEDITERRANEAN

For me, the Mediterranean has two aspects: the one landscape lush and smelling of jasmine, as on Capri and the nearby Sorrentine coast; the other bone-dry and dotted with whitewashed architecture, as on the Aegean island of Mykonos. Both provide an ideal setting for the full flowering of human potential—warm enough for the body, cool enough for the intellect. Here, as I watch the sun go down over Homer's wine-dark sea and listen to a cassette of Satie's *Gymnopédies*, life can be at its simplest yet most profound.

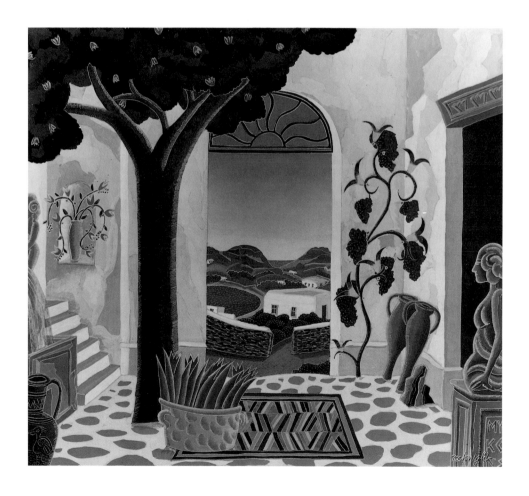

114

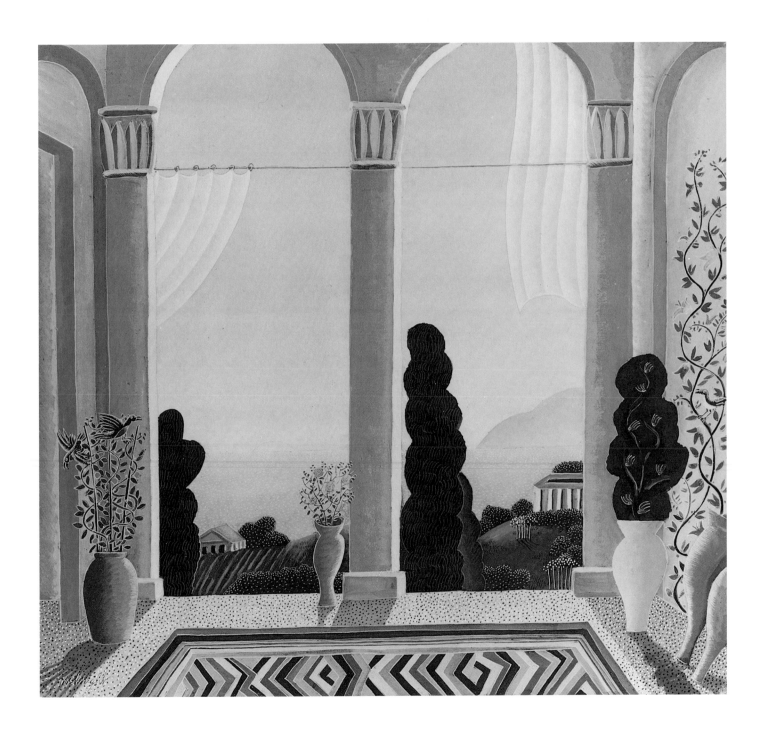

Restaurant in the Midi.
1980. Casein on
canvas, 22 × 28″.
Private collection

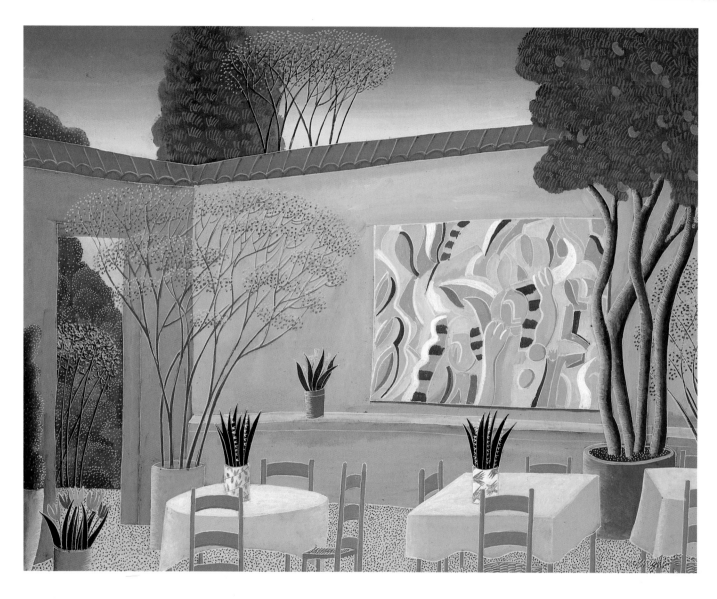

Mykonos Chapel. 1984.
Casein on paper, 16 × 18″.
Collection the artist

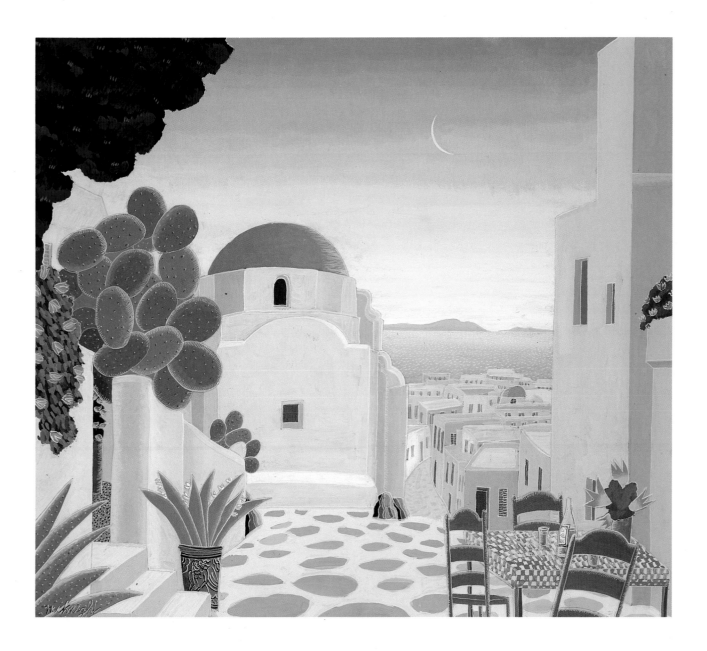

MEDITERRANEAN

Left
Brancusi's Studio. 1980.
Casein on canvas,
24 × 26″. Collection
Mr. Debare Saunders,
New York

Room in the Cyclades. 1979.
Casein on canvas,
36 × 40″. Collection
Mr. Alan R. Gronsbell,
New York

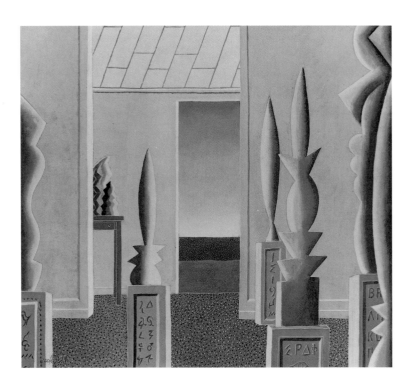

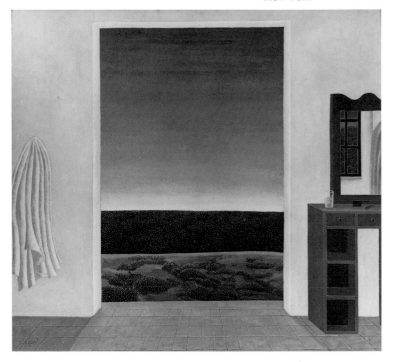

Cycladic Room. 1983. Casein
on canvas, 28 × 30″.
Chalk & Vermilion Fine Arts, Ltd.,
New York

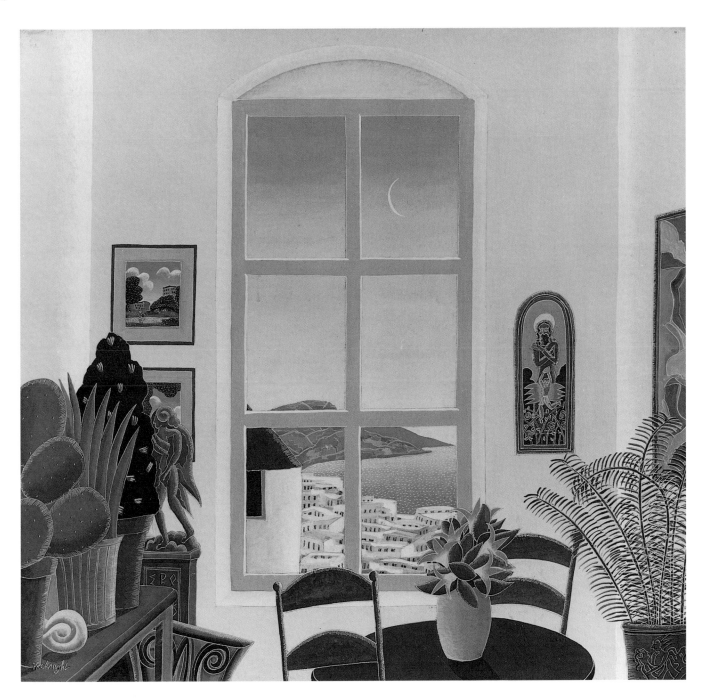

Valencia. 1983.
Silkscreen, 24 × 25⅞″

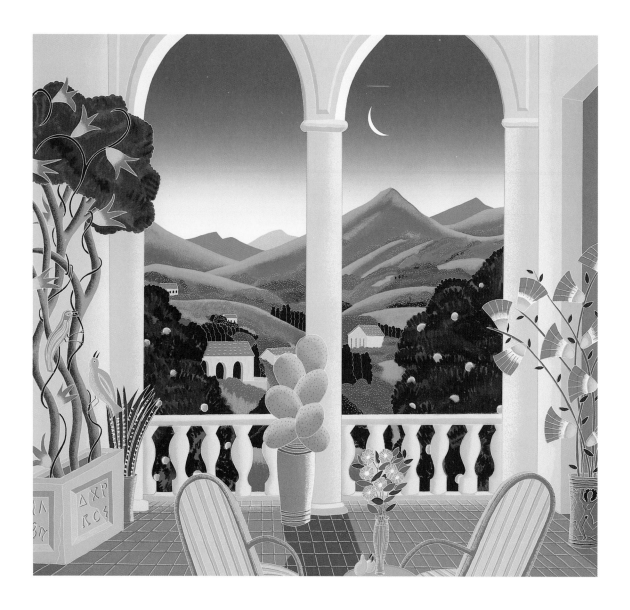